Photographing
Horses

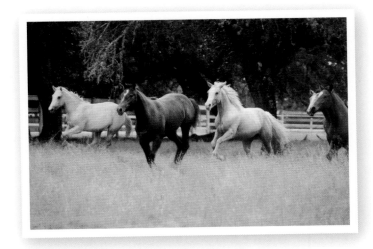

Lesli Groves

Photographing Horses

How to Capture the Perfect Equine Image

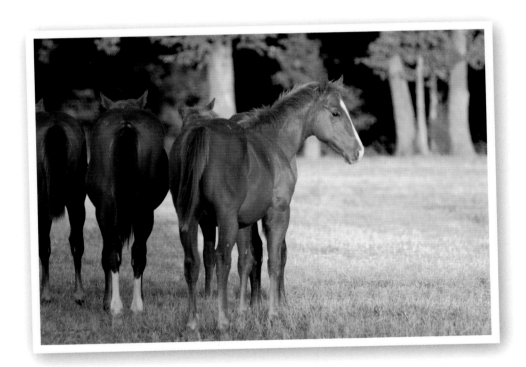

THE LYONS PRESS
Guilford, Connecticut
An imprint of The Globe Pequot Press

To buy books in quantity for corporate use
or incentives, call **(800) 962–0973, ext. 4551,**
or e-mail **premiums@GlobePequot.com.**

The Lyons Press is an imprint of The Globe Pequot Press.

10 9 8 7 6 5 4 3 2

Printed in China
Designed by Diane Gleba Hall

ISBN-13: 978-159228-230-2
ISBN-10: 1-59228-230-X

Library of Congress Cataloging-in-Publication Data is available on file.

This book is dedicated to my parents:
the late Rosalie Cicutto Krause, who was love personified,
and Gene Krause, who set my career path early by sharing
his knowledge and appreciation of art and horses.

Contents

Introduction

THIS BOOK IS FOR PEOPLE WITH AN AFFINITY FOR HORSES, REGARDLESS of their affinity for cameras.

Logically, they have the greatest appreciation for better horse pictures, even if they don't have a clue how to take them.

Chapter 1 begins by presuming the reader has no real interest in the fine art of photography, but has a need or desire for a picture that does not sabotage a horse's appearance.

The Simple Recipe in chapter 1 allows you to get acceptable results using any camera, including one-time-use or disposable cameras, with very little effort. It circumvents the two most common mistakes people don't know they make. It's instant gratification for those who just want a decent picture of their horse without having to learn *too much* about it.

Success at this level often inspires a greater interest in photography, which can reward horse lovers in ways they cannot anticipate. "A camera teaches you how to see without a camera," said Dorothea Lange, an influential photojournalist of the Depression Era. Through the camera you develop a more discerning eye for horses. You distinguish more in their

individual conformation and the dynamics of their movement, their expressions and behavior. You recognize the ephemeral quality of light and how it affects what we see. The world simply becomes a more interesting place.

Much of this book is devoted to setting up shots that don't require a lot of technical expertise or expensive equipment, with emphasis on the classic profile. Everything you learn about lighting, background, working with other people, and thinking from the horse's perspective in order to shoot the classic profile applies to any other type of shots you want to take.

Chapter 2 is an overview of horse photography and a comprehensive look at the many factors that affect the photo shoot and resulting image.

Chapters 3 through 12 isolate several of these major factors for a closer look. Photography means "writing with light," and becoming aware of light's impact is the first step to improving your future pictures. The subsequent chapters deal with camera considerations, locations, backgrounds, and how to work with the horse and handler. Concentrate on each separately before you are out in the field. It will help you put them all together when you have your subject in front of you.

Chapter 6 offers a secret shortcut to becoming a high-percentage shooter: the model horse exercise. Though this exercise never excites people the way photographing live horses does, novice photographers assimilate the basics faster with a subject that doesn't move. They enjoy the first live horse session more, they develop confidence, and they get infinitely better results.

Taking portraits of horses and people together—a specialty within a specialty— is the subject of chapter 13. While it is a challenge, the result can be greater than the sum of its parts, creating memorable photographs that have great significance for those who care about the people or horses involved.

Chapter 14 on action photography will help you assess if your camera is up to the job and how to work around its limitations. While setups for some of the standard action shots are included, please use your imagination to look for more.

Chapter 15, on taking your camera along for the ride, will help you whether you're actually going along on a ride or just taking pictures of other riders in the wide open spaces.

The final chapter is a bonus. Video is a great way to capture an event, measure training progress, school a rider, or market a horse. This chapter includes general advice on recording the horse in action, as well as producing a horse marketing video.

Most of this book focuses on techniques specific to horse photography rather than technical settings. Today there is little uniformity among camera models, and technology seems to constantly change. Your camera owner's manual is a good source for additional specific information and advice. The staff at professional camera stores or photo labs can also be helpful.

The arrangement and presentation of information in this book was influenced by my own experience as a perpetual student, professional photographer, magazine editor, and mentor to other photographers.

My first photography class derailed my interest in photography. Had I been introduced to horsemanship the same way, I don't know what the results would have been. Hours of lectures about history, mechanics, chemistry, and technical phenomenon related to photography drifted right over my head, because we weren't taking any pictures to see how it all related.

After enduring the lectures for weeks, we were sent out in the field by ourselves to shoot our first assignment. I'd been loaned an antique, medium-format camera worthy of Ansel Adams but baffling to me. It was like putting a first-time rider on a racehorse. An exposure guide printed in German was affixed to the camera body, but there was no owner's manual.

Before we could see the results of our elementary efforts, we had to learn to develop the film and print the pictures. Then the teacher hypothesized what we'd done wrong—in my case it was hard to tell because only the left-hand third of my negatives had been immersed in the developer. (Our instructions were for 35mm film, and the film for the medium-format camera I'd borrowed was a different size.)

We shot and developed one more roll—twelve more shots—and the semester was over.

I did not sign up for Photography II.

The academic approach works, eventually. But the basic Simple Recipe is closer to the way I learned to take livestock pictures. Getting decent results right away inspired a chain reaction, and learning the technical aspects of photography seemed easier and more imperative.

I worked for a livestock advertising agency, and my boss wanted to teach me how to take conformation pictures of purebred cattle for ads and auction catalogs, one of the services the agency provided. He took me along on a shoot, explained the goal, set the camera for me, and let me shoot around him. When we got the proof sheets back he realized he hadn't shown me how to "zoom" the telephoto lens out. My cattle appeared dwarfed and much farther out on the horizon than his. Nonetheless, a few days later, he sent me in his place to take pictures for an important client's upcoming ad.

I felt like an imposter.

The ranch manager left me alone in a pasture full of black cows. Did he assume I could handle it, or did he consider the venture a waste of time? Typically someone would stay to "get ears," the term for attracting the animal's attention so its ears are pricked forward and it looks alert. Perhaps I insisted on solitude, so no one would see me fumble. The part I vividly remember is kneeling down in sun-bleached grass to focus on one big, feminine cow that had ambled cooperatively into a balanced pose and stood there, poised, gazing into the distance.

Recalling this makes me appreciate a photograph's ability to stimulate memories of details we would otherwise forget.

When the editor of *The Cattleman* magazine dropped by our office and looked at the freshly printed proof sheet, he circled one frame and told my co-workers it was "the perfect cow picture."

Our art director dubbed her "The Perfect Cow." She earned my first magazine cover for me.

During this time, I also had a part-time job drawing and coloring markings onto horses' registration papers. We drew the markings from series of four photos the owners sent to the breed association in order to

document their horses. That's when I discovered that distorted, unflattering pictures are not the exception, but more commonly the rule.

I studied those bad pictures in order to draw the markings, but also because I wanted to learn from their shortcomings. Being more or less forced to look at so many bad pictures made me realize they were generally plagued by two common mistakes. The problems were simple to prevent, but not the type of things nonphotographers would pick up on their own.

Those early experiences resulted in the Simple Recipe in the next chapter.

"The Perfect Cow" represented a turning point in my career; from then on I was considered a natural-born photographer. At first, photography was primarily a means to an end. It was a way to get a picture. Then it became a way to advertise a horse or cow. Then it was a way to get a press pass to a horse show, rodeo, or other activity where I wanted to be closer to the action than a general admission ticket would allow. But somewhere along the way it became a way to tell a story, or to memorialize a horse or person or a person's relationship with a particular horse.

Recently I realized I enjoy the challenge of the process as much as the end result, the way a fly fisherman or hunter must feel, or a horseman bringing along a horse in training.

I had some built-in advantages when it came to taking pictures of horses and cattle, but then everyone does. Photography, like horsemanship, is both an art and a science. Regardless of which side of your brain is dominant, there will be some aspect that comes more naturally to you and some aspect you have to concentrate on a little harder.

My advantages resulted from my privileged youth. I was never without a horse and was taught, by example, to appreciate horsemanship. My father started quietly passing his formal art education on to me as soon as I could grasp a crayon and make a mark. He used the ads in *The Quarter Horse Journal* to explain layout and design. I used to trace the photographs. One childhood fantasy was to work for the *Journal*, and after taking several thousand pictures of purebred cows and having several freelance articles

published, I got the opportunity. In addition to increasing and broadening the scope of my own photo experience, I got an enhanced view of the work of a wide range of horse photographers. That allowed me to mentor others and later to teach equine photojournalism at Rocky Mountain College.

The success of those developing photographers inspired this book, although I often wish I'd picked a subject with greater universal appeal and less significance to me, personally—something like "The Meaning of Life for Dummies." It would have been much easier.

Horse photography does not lend itself to a traditional how-to approach, except at the most elementary level. It is not like paint-by-numbers. We don't all have the same expectations, nor are we working with predictable ingredients. And that's the beauty of it. Our photos are unique images of unique individuals.

Writing this book has often reminded me of how frustrated I was the first time I met the legendary horseman Tom Dorrance. Tom had unintentionally become famous through the horsemen he'd influenced, most notably Ray Hunt. As a teenager, I'd heard Tom's approach described by Jack Brainard, another tremendous horseman, and the lesson had influenced the way I approached the cattle I photographed. When Tom agreed to let me interview him for a story—a rare privilege in those days—I expected him to provide the ultimate how-to guide for mastering horsemanship. But every time I asked him a question about how he'd do something, the answer was some variation of "It depends."

Horse photography is not like paint-by-numbers.

⋀

I wanted specific answers. They translate more easily to the printed page. And I felt a tremendous obligation to channel Tom's wisdom to our readers in a way they could easily absorb and use.

I feel that same obligation now regarding what I've learned from others and through my own experience regarding horse photography. But as I anticipate the questions people have regarding what they should do, choose, expect, or use, quite often the best answer is, "It depends."

This text provides information to help you make decisions in your particular situation. Between the lines, I hope you'll find inspiration as well.

Photographing
Horses

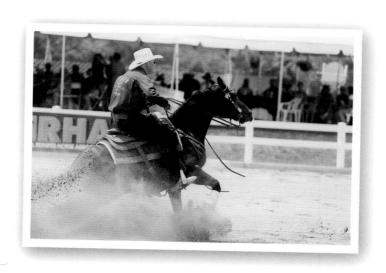

1

The Simple Recipe for

Taking a Horse Picture

Ingredients:
Sunshine
Camera
Horse

PHOTOS CAN MAKE A HORSE LOOK UNBALANCED, COARSE, OR POT-bellied and make his head look like a moose. So before we discuss the finer points that will allow you to take better horse pictures, let's learn how to avoid bad pictures.

Most horse pictures are taken by people with a much greater interest in the horse than in photography. And the results are often downright insulting to the horse.

If you know the horse, you might not see the problem. Your brain recognizes the image as an icon of all you know the horse to be. But people who've never seen the horse may see it differently. And most aren't evaluating the photo; they're evaluating the horse. If the image is unflattering, they don't think, "That's not a very good picture." They think, "That's not a very good horse."

(Horse-trading publications are full of examples. And we can assume the naive photographers had better intentions, since someone they know has a financial stake in the horse. If your objective is to take a picture for

reproduction in an advertisement, consider hiring a horse photographer, not only for their expertise, but because they've invested in professional equipment that will yield the best results.)

The Simple Recipe is designed to let anyone get a decent horse picture using any camera, with little extra effort. It circumvents the two most common mistakes made by novice photographers when taking horse pictures. And it's a solid foundation you can build on using experience and the information in the rest of this book.

Since we learn through repetition, it's repeated here three times, each time with a little more information.

The Simple Recipe at its simplest

1. Position the horse so his profile is in direct light—so the sun is shining directly on his side and his shadow is falling directly behind him.
2. Zoom the camera out to the telephoto setting and take a picture of his profile.

When I look through ads for horses containing photos taken by fledgling photographers, I always think to myself, "If people just knew to do two

> **Using a typical lens** instead of a telephoto lens, this is the result when you shoot from a front angle rather than shooting the profile. Notice how long her front legs look compared to the back, how big her head looks compared to her hindquarters.

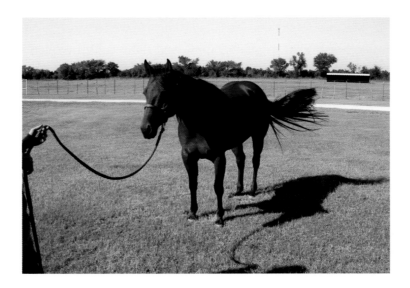

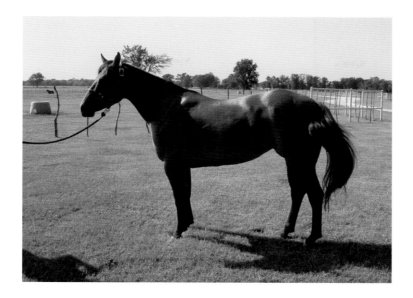

❮ **The sun** is behind the horse, instead of behind the photographer. If you were looking at this horse in the flesh, you would see more detail in the shadow areas than the camera does, so you might not realize it's a problem.

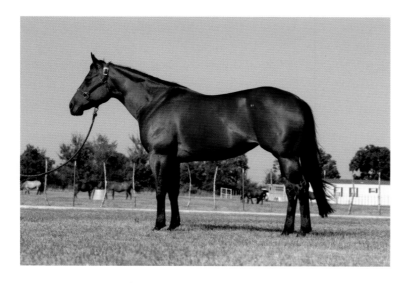

❮ **Direct lighting** and a telephoto lens portrayed the horse more accurately. This photo was taken according to the directions in the Simple Recipe, with one helper and not a lot of concern about the background. Ideally we would have waited a couple more hours to take the shot, when the sun was closer to the horizon, as discussed in chapter 3. We would have spent more time scouting locations (chapter 7) and more effort setting up the shot and getting an animated expression (chapter 9). And we wouldn't have had to deal with a frequently swishing tail (fly spray, chapter 8).

things, the horse would look so much better." They wouldn't have to know *why* they needed these two pointers, or why the advice works. This is a universal starting place.

The Simple Recipe

1. Move the horse so that his profile is parallel to the sun and his shadow falls directly behind his profile.

2. Zoom your camera to the telephoto setting. If your camera does not have a telephoto setting, resist the temptation to fill the viewfinder with his image—in other words, stand back farther so his image doesn't completely fill the frame. (This relates to lens dynamics, explained in ch. 4, p. 43–49.) You may have some extraneous background surrounding him which you can crop out later, but you'll avoid the distorted effect upon the horse caused by a wide-angle lens setting.

3. Stand approximately 35 feet away from the horse, in line with the base of the horse's withers. The exact distance is going to depend upon the focal length of your lens (discussed in ch. 4, p. 43). An experienced photographer doesn't measure the distance from the horse in order to pick a spot from which to shoot. Instead, he sets the lens and then moves into position based upon where he needs to be to frame his shot (in other words, to get what he wants in the picture).

4. Kneel down to lower your camera angle closer to the center of the horse.

5. Wait for the horse's ears to point forward.

6. Click!

Why use the profile pose

The profile is the easiest and fastest conformation shot. It is a natural pose for the horse, a stance that he will easily take and maintain.

The horse is parallel to the camera and what is called the film plane, which simplifies the technical aspects. Distortion, depth of field, and critical focus become more of an issue when you shoot a head shot or a three-quarter-front or a three-quarter-hind view.

When people ask "What's wrong with this picture?" the two most common responses are, "Unflattering shadows," and/or, "Distortion from a wide-angle lens."

The camera tends to dramatize the difference between light and shadow areas. The differences seem stark compared to what we see in person. The shadows can also distort the horse's appearance, and that's why we attempt to eliminate them by positioning the horse in the way described.

Distortion from a wide-angle lens at close range can alter a horse's appearance dramatically and not in a good way. It works sort of like the fun-house mirror at the carnival. The camera *angle* creates additional distortion, which is why the photographer positions himself as described, close to the center of the horse, parallel to his profile. If you use a wide-angle lens at close range and stand near the horse's head, his head will look freakishly large and his hindquarters will shrink. From the rear, the hindquarters will seem disproportionately large, his neck will seem disproportionately short, and his head will look too small to contain a normal brain.

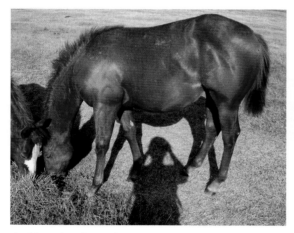

Shooting from close range with a wide-angle lens, similar to a one-time-use or point-and-shoot camera with a fixed lens, made this filly look long-backed, potbellied and short-legged. Of course, the pose didn't help.

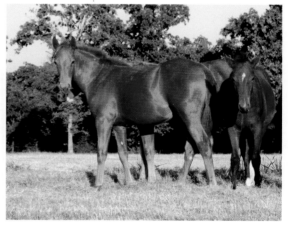

Compare the same filly's proportions when seen through a telephoto lens and from a lower angle.

The Simple Recipe, with a few more details

1. Select your camera settings
 a. Select an ISO of 400 (either 400 ISO film or a digital setting of 400 ISO, if you have that option). ISO numbers relate to light sensitivity whether in film or digital photography (discussed in ch. 5).
 b. If you have an adjustable camera, use shutter priority mode and set your shutter speed at '125,' or use "action" mode (the icon might be a person running or swinging a golf club).

 (With some cameras this might be unnecessary. "Point-and-shoot" cameras tend to use their fastest shutter speed to make the proper exposure—in other words, they appear to be programmed for "shutter priority" anyway, so far as picking the fastest shutter speed. Also, if a camera has a "portrait" mode, it usually automatically extends the lens out to the longest focal length, which is what you'd want if you were taking a close-up of a person. It's also what you want to take a photo of your horse.)
 c. Zoom the lens to telephoto—extend it as far as possible—and leave it there (the one tree icon vs. the three trees icon, "T" vs. "W"). If you're lucky enough to have a super telephoto lens, you only need to be in the 90- to 100-mm range. (If you used 300mm, you'll have to stand in the next county.)

 If your camera's lens doesn't zoom, it is probably not a telephoto lens. You still need to stand farther away from the horse and resist the temptation to fill the frame with the horse.
2. Have the horse led into position and posed with all four feet showing. The broad side of the horse should be in full, direct sunlight, which is best achieved in the early morning or late afternoon. His shadow should fall directly behind him.

 Obviously, you want a nice background, but the horse's position relative to the sun—the light source—is your first criterion.
3. Get in position and frame your shot.
 a. Face the horse, with the sun directly to your back. (Your shadow will fall directly in front of you and point toward the broad side of the horse.)

b. Look through your viewfinder, and step either back or forward until the horse is framed in the viewfinder. You should be able to see the entire horse. Be careful not to cut off feet, tail, hooves, ears, etc. *DO NOT* adjust the lens from telephoto. Instead, adjust where you are standing.

c. Align yourself at a point slightly behind his withers.

d. Kneel down to lower your camera angle.

e. Focus on the vertical line created by the contrast between his front leg and the background.

4. Anticipate when his ears pivot forward. Once his ears are forward, then CLICK.

2

The Big Picture

The many factors that influence the ultimate image

WHEN WE LOOK AT A HORSE IN THE FLESH, WITHOUT TRYING TO visualize how the camera sees it, our eyes and amazing brains automatically compensate for all kinds of things. Light and shadows, background, motion, and even *emotion* are filtered through our subconscious in the creation of our mental image.

That's one reason fledgling photographers are disappointed when they see prints of the pictures they've taken. They simply aren't aware of everything in front of them until the camera captures it for closer inspection. For example, when they focus on the horse, they don't notice the fence post behind his head, but it makes him look like a unicorn in the resulting print.

When you first start developing the photographer's ability to simultaneously see, think, and do, you'll be doing well to recognize when the horse is standing still and has his ears forward and capture the shot. As your reflexes and responses continue to evolve, you'll be able to see more, in greater detail, and faster. You'll have more control over your results.

There's no formula for perfect pictures, for two reasons. Each situation is different—not only is each horse different, the environment, helpers, and objectives are different. Moreover, the merit of any photograph is highly subjective, depending on the viewer.

A picture of a horse can have all the elements of a good photograph, as defined by photography experts, and still not impress a horseman.

A horseman's definition of a good horse photo would be one in which the subject looks like a good horse. That seems like it should be simple for anyone with a camera, given horses' inherent beauty. But if you look at many pictures taken by novice photographers you know better.

Novice photographers are unaware of how light, lenses, camera angles, and background elements affect the ultimate image. Therefore,

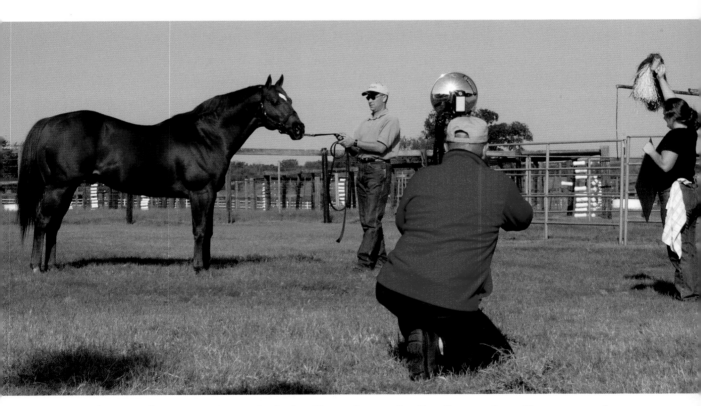

△ **Many factors** influence your pictures. Professional horse photographer Don Shugart, pictured here, says people skills are more important to his trade than a technical understanding of photography.

<A picture of a horse can have all the elements of a good photograph, as defined by photography experts, and still not impress a horseman. The horse's head is out of proportion to his neck and body because of the camera angle and wide-angle lens. However, the image has sound pictorial composition. These type of images often appear in mainstream magazines and galleries, because flattering the horse is not their objective.

their pictures often distort the horse's appearance in a negative way. Sometimes very negative.

Accomplished photographers may know more about cameras or composition, but few understand what is flattering or unflattering to a horse. When horse owners hire a photographer listed in the Yellow Pages to take "professional" pictures of their horses, the horseman is usually disappointed with the outcome and the professional photographer is baffled because he doesn't see a problem. No doubt the photos are perfectly focused and exposed. The background is simple and uncluttered. But they don't make the horse look good—not by horseman standards, beauty being in the eye of the beholder and all.

Photographers rate an image by artistic value and technical execution. They tend to think of horses as pictorial elements, abstract shapes, and colors. They concentrate on the photo's composition rather than the horse's conformation.

The pictures of horses that people frame and hang on their wall fall into two broad categories reflective of these two perspectives: documentary and artistic.

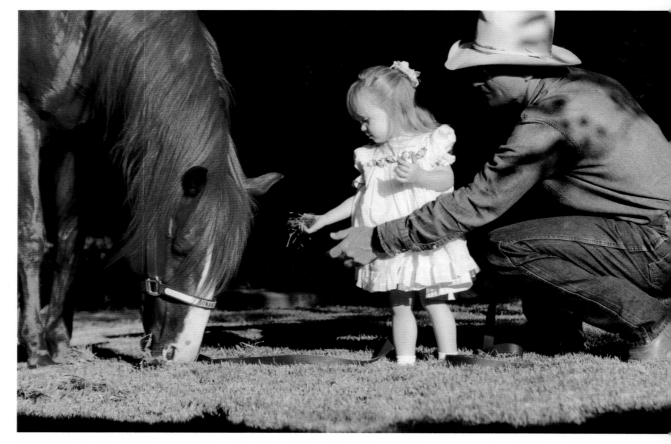

⌃ **On this day,** the objective was conformation shots of the stallion. Afterward, if time permitted, we'd photograph the little girl with her brother. Dad didn't plan to be in any pictures, but this scene presented itself as we waited on the horse to lose interest in the grass. When you take pictures of horses and people together, look at the way the figures interrelate.

Documentary photos are taken with the primary objective of creating a record of that horse—the ones in which hopefully the horse looks like a good horse. They may be conformation shots, action photos, or snapshots of you and your horse in the backyard. These include commissioned portraits, "win" photos, or those that accompany show, race, or rodeo results.

Artistic photos are the images you keep because they are pretty or provocative in some way, because you like the colors or the mood. They have abstract appeal and are well-composed according to the principles

of design. It doesn't matter to whom the horses belong, their ancestry, descendants, or accomplishments. You see them in coffee-table books and on calendars and coffee mugs. They may be panoramic group shots or perhaps zoomed in tightly or taken from acute angles or with fish-eye lenses. They might be soft focus, blurred, or grainy. (When you get these effects unintentionally, say you were going for "art").

Documentary and artistic are not mutually exclusive designations. The best documentary photos will also have abstract appeal and sound composition according to the principles of design.

Regardless of your objective, your results depend on several factors.

Successful horse photographers, like all photographers, learn to control negative optical illusions and create positive ones through the coordination of light and shadow, background, lenses, choice of camera settings, patience, timing, and luck.

Inexperienced picture-takers give too much credit to the camera and luck. The camera doesn't take the picture, the photographer does. As for luck, competitive horsemen will tell you that luck is when preparation meets opportunity. They will also tell you that you make your own luck. That also applies to photography.

To increase your luck, take a broader look at the big picture, the multitude of things that influence either the photo shoot or the resulting images. Many of them are interrelated. Some you can control, some you can influence or improve, and some you have to accept and work around. And the combinations are different in almost every situation. That's what keeps it interesting!

It's funny how people get so worried about the camera and camera settings they forget they are dealing with a large animal with a mind of its own.

⋀

Your objective: Are you trying to document a particular horse? Is this an advertising photo? Are you setting up the photo or are you looking for candid shots? Do you just want a snapshot to remember a certain setting or event? Are you including a person with the horse? Your objective will determine many of your decisions, like how much effort you're willing to go to, whether or not you need additional help, etc.

Circumstances may force you to modify your objective. Sometimes the pictures you didn't anticipate turn out better than the ones you went after in the first place.

The sun: The available light determines your choice in backgrounds, your camera settings, the contrast and brightness of the photo. Because we can't control Mother Nature and the quality and direction of the available light, and because it is ever-changing, it is a primary consideration. It is so important we devoted the next chapter to it.

∨ **The golden** quality and direction of the light when the sun is near the horizon makes it the ideal time to photograph horses.

The horse, or horses: The horse influences many of your decisions. How easy is he to handle? What will get his attention? Would he do better loose in a pasture? Under saddle? When he's fresh? How long before he gets bored? Which is his "best side"? Does he have a buddy that he can't stand

<A slick, shiny coat and strong, direct light give the horse a more three-dimensional appearance and show details in his muscling.

to be without? An understanding of horses goes a long way toward getting better horse pictures.

The horse's color is an important factor, as it will influence your decisions about the photo's background. Also, light-colored surfaces tend to reflect light and darker colors absorb it, so at a nitpicking level his color can influence your exposure settings.

Taking pictures of two or more horses together changes strategy as well.

Condition and grooming: A horse's summer coat is usually more photogenic than a winter coat because his muscling is more apparent; therefore he doesn't appear as flat in the photo. Don't expect the horse in your pictures to look like the gleaming creatures in the ads in show publications if he wasn't gleaming when you took his picture.

Conformation and breed or event standards: These will influence what you emphasize or de-emphasize through camera angles, choices in background, poses, etc. Study breed or event publications to develop your eye for what is considered appealing and then try to re-create it in your own photos.

⋀ **In addition** to standard documentary approaches, look for other ways to capture the inherent beauty in horses. The light in this candid photo was both diffused and reflected by the white tent under which this girl and her horse stood. Notice the highlights in the horse's eyes, provided by the light "bouncing" off the tent walls, which created the minimalist background.

The environment: How much influence do you have to make things more conducive to better pictures? What other activities are taking place, and where? Are the people around you rushed or anxious? Which direction is the barn from the spot where you're taking pictures? Can you have something moved if it interferes with the background?

The human factor: Here's a little-known horse photography secret: other people have a great deal of impact on the results or your photo session. Sometimes positive. Sometimes . . . let's just say that diplomacy and communication on your part will have direct bearing on your luck.

Timing: The cowboy philosopher Baxter Black says that timing is everything to the success of a rain dance. Timing is also critical to the success of your photos. It includes the timing of the photo session itself. Time the session to take advantage of the early morning or late afternoon light on a day when the weather is cooperative. Time it so it doesn't interfere with the feeding schedule. Even when you are photographing a horse that is standing still, anticipate the moment when he is most expressive. Obviously, timing is critical to action photography. One of the benefits of digital photography is that you can see the results right away and find out if you tend to release the shutter too early or too late, and adjust right away.

▲ **Who says** photos don't lie? Horse photographers learn to avoid negative optical illusions and create positive ones through the coordination of light and shadow, background, lenses, choice of camera settings, patience, timing, and luck.

The background: Your background will depend on the direction of the available light and what's nearby. It also depends on your objective. If it's a portrait, you want a plain background. If it's a snapshot at a show, add something in the background or foreground that shows the viewer something specific about the setting.

Foreground: If the horse is your subject, anything between the horse and the camera is the foreground. Typically we don't give it much consideration in portraiture as long as it is not distracting. Lack of interesting foreground and strong direct light make our horse portraits seem flat by artistic standards, although effective for documentary purposes.

Camera angles: The angle from which you choose to shoot will depend upon your objective, the direction of the light, and whether you are using a wide-angle, normal, or telephoto lens. Acute

 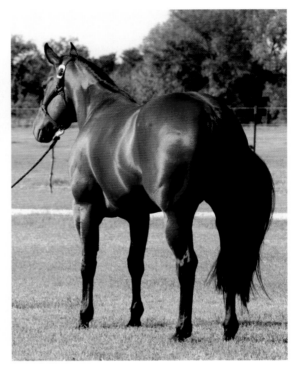

△ **Different lenses,** camera angles, and poses affect the appearance of the horse's proportions.

camera angles can create distortion, especially with wide-angle lenses. But small adjustments in camera angles can actually work in your favor, either to enhance or minimize some aspect of the horse's conformation, or to change his relationship to the background.

Lenses: A telephoto or "zoom" lens is almost a necessity for all but profile poses. Explained in greater detail in a following chapter, the lens you have available will affect which type of shots you can take and the quality of your finished print.

The pose: Certain poses have become classic because they are more flattering to the horse. The keyword is balance. If you study a lot of good horse pictures, when you are looking through the viewfinder you will have an "Aha" moment of recognition when the horse is posed nicely.

Expression: The horse's expression in the photograph makes a huge difference in our perception of him and the photograph. It is influenced by his temperament, the environment, your ability to anticipate and time your shot, and, in a portrait situation, the cooperation of other people to engage him off-camera.

The camera: Know your camera's limitations and plan your shots accordingly. People often ask me what camera they should use to take horse pictures, as if they owned several and needed help making a choice. The industry standard is a 35mm single-lens-reflex, or SLR, with a telephoto lens. However, if you don't know what that means you probably don't need to run out and buy one until you get a little more experience with the camera

⌄ **The horse's expression** influences our perception of him and the photograph. This champion race-horse looked more like a bored plow horse until someone led a mare out of an adjacent barn.

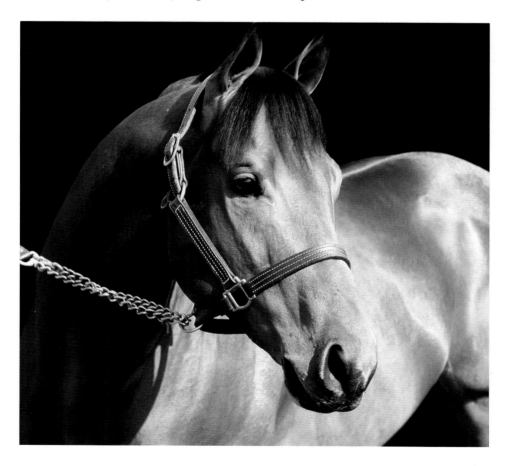

◁ **Cropping** the original allows you to delete extraneous or distracting elements, or change the balance of the elements in the photo. The only disadvantage is that when you crop this much you can't enlarge it much without it becoming grainy or pixelated.

you have, or a point and shoot model that zooms. You might want to be sure you have the temperament for horse photography, which is just as important as the equipment, before you make a significant investment.

That said, many current digital camera models challenge your patience when taking horse pictures because of what's called "pre-shutter lag." It means there's a delay between the instant you press the shutter release and when the image is recorded. Manufacturers don't like to point it out because it will cause you to miss shots requiring split-second timing.

Camera settings: Automated cameras have obvious benefits, but for greater creative control and to get the most out of every situation, you need to learn the technical aspects of photography. First lesson: everything is a trade-off. The settings interrelate. Changing the ISO, f-stop, or shutter speed affects the other two as well. While the technicalities can be confusing at first, fear not. They will make a lot more sense as you continue to take your own pictures and reread the explanations.

Framing: Looking through the camera's viewfinder "frames" your subject—you anticipate what the photograph will look like. The way you choose to frame your subject will depend upon your objective and the background and foreground. For example, with portraits and action shots, we usually leave more space in front of the horse than behind.

Cropping: After you take a picture, you have an opportunity to fine-tune it through cropping, which might best be described as redefining the edges. This allows you to delete extraneous or distracting elements, or change the balance of the elements in the photo.

After every photo session you should carefully analyze the results in any case, if your goal is to improve. If you're cropping digital images on the computer, save it several different ways and compare the results. If you're cropping prints, Sticky Notes ™ are ideal because you can re-adjust as many times as you like and they stay put. Students are often pleasantly surprised when I show them the better picture within their original picture.

A hint: Crop your picture the way it looks best to you, without worrying about whether it adheres to standard photo proportions. You'll notice the pictures you admire in books and magazines don't always adhere to the one-hour photo lab's standard 4x6 proportion.

Photo-finishing: Print-making or photo reproduction is perhaps the most underappreciated aspect of photography. While minilabs are convenient and inexpensive, the degree of automation that allows them to be so cheap and convenient often results in mediocre and erratic results.

Typically, for documentary or advertising photos of a particular horse, we want the results to be printed lighter than what the machine assumes, to show more detail in the horse. This is especially true in darker-colored horses.

To get the best results from a minilab you need to have some experience with a professional lab. Serious photographers develop a relationship with their photo lab, much like the relationship that horsemen develop

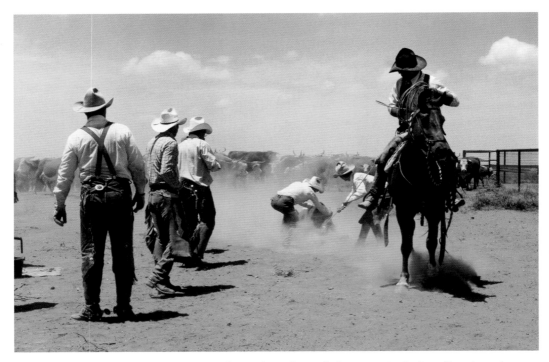

∧ **What is closest** to the camera appears larger than what is farther away. In the branding photo the difference enhances the composition by creating a leading line and perspective, but it also makes the horse's head look larger. With a wide-angle lens, the effect is even more dramatic.

with their veterinarian or farrier. The better labs consider talking to their customers about their prints and how to improve them part of their customer service.

If you compare your pictures to those in horse magazines, be aware that many of those photos have been digitally altered to change the background, remove distractions, or tame a blowing mane. None of the photos in this book have been retouched in that way.

Composition: In this context, composition means the artistic arrangement of the parts of a picture. Horse photographers don't always think in detail about composition. For most people, and especially novices, it is an afterthought, subservient to documenting the horse. But as you become more comfortable, start looking at the horse and the elements in

the background as abstract shapes. Notice how the dominant mass—the horse—interacts with the abstract forms in the background.

It is not within the scope of this book to teach composition as such, only to stress the importance of it to those who would take horse photography to a higher level. One of my favorite books on the subject is a children's book: *Picture This, Perception and Composition*, by Molly Bang. A more in-depth source is *The Art of Color and Design*, by Maitland Graves.

Factors that influence the ultimate image

Your objective

The sun

The horse, or horses

Condition and grooming

Conformation and breed or event standards

The environment

The human factor

Timing

The background

Foreground

Camera angles

Lens focal length

The pose

Expression

The camera

Camera settings

Framing

Cropping

Photo-finishing

Composition

3

Learning to See the Light

Light can enhance a horse's appearance in a photo or detract from it.
This chapter raises your awareness and teaches you how to use light
to your advantage.

THE QUALITY AND DIRECTION OF THE LIGHT ILLUMINATING THE horse you're photographing has more impact on the outcome of your picture than which camera or lens you are using. And light is free! You just need to concentrate on learning to see it the way your oh-so-critical camera does.

The model horse exercise in chapter 6 is an outstanding way to accomplish that. Looking at the pictures others have taken will help, but— like anything—the best way to reach a greater level of understanding is by trying it on your own.

Light can enhance a horse's appearance in a photo or detract from it. The effects, especially negative ones, are more obvious in a photograph than when you are looking at the horse in the flesh. Our brains seem to compensate for the contrast between highlight and shadow and shifts in the color of light in a way the camera does not.

When I talk about seeing the light, I mean first of all becoming aware of the intensity and color of the light, which is influenced by the time of day and atmospheric conditions. Then, more specifically, look at the way the light falls on the subject and the highlights and shadows it creates.

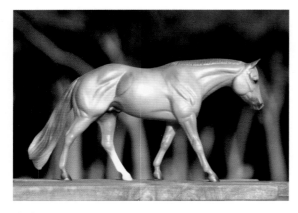

△ 9 a.m.

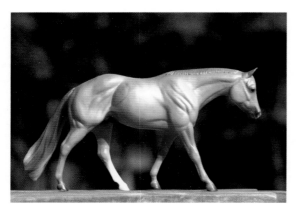

△ 11 a.m.

△ 1 p.m.

Becoming aware of the intensity and color of light will help you decide in broad terms when you want to be outside shooting, and looking at the way the light falls on the horse will help you decide which specific shots to take.

If your goal is to flatter a horse's appearance and conformation, then sunny days are preferable. Direct sunlight is more intense than sunlight diffused through clouds or fog. The brighter light and contrasting shadows add contour and definition to his muscles and make him appear more three-dimensional, less flat. The reflection of the sun on his coat makes it shinier, and the light in his eye makes him look more alert.

However, you have to be conscious of where the highlights and shadows are falling before you take the picture. They can easily create unflattering distortion. Not being aware of the horse's position relative to the sun and the effect of the shadows is a common mistake in otherwise good pictures.

Nature photographers advise shooting in the early morning and late afternoon because of the warmer color qualities of light at that time, when the sun appears closer to the horizon.* That's one reason to schedule your horse

* The explanation for the golden glow: To reach us, light waves of color must travel from the sun and through our atmosphere, which acts as a filter. Because of the curvature of the earth, at sunup and sundown these light waves must travel through more of our atmosphere than when they come from directly overhead at midday. As these light waves swim through

⋀ **Compare the difference** when the same object is photographed on a cloudy day versus a sunny day. On a cloudy day, objects tend to appear flat, because the diffused light has reduced the contrast level between light and shadow.

pictures for that time, but the other reason is because the direction of the light is more flattering to the horse.

Compare the lighting, and its effect on the model horse, in these pictures taken at 9 AM, 11 AM, and 1 PM. Notice the earlier shot has more of a "golden glow" about it, which enhances the model horse's color.

When the sun is more directly overhead, shining down on the horse during the middle of the day, the resulting shadows make him look coarse and potbellied. When the sun appears closer to the horizon in the early morning and late afternoon, it illuminates the horse from a lower angle, which is more flattering.

For a classic horse portrait, we not only want the light from this lower angle, we want it shining directly on the horse's profile. Since we can't move the sun, we move the horse.

This is why in the Simple Recipe, we said to keep your back to the sun and the horse directly in front of you. Another way to think of it: Watch

our thick atmosphere, the shorter wavelengths on the cool end of the spectrum get lost in atmospheric dust and water and cannot reach us. This leaves the longer, warmer waves of light to penetrate our atmosphere and illuminate our subjects.

As the sun climbs higher into the sky, it shines more directly through our atmosphere, allowing the shorter, cooler wavelengths to reach us, and balancing the color of the light.

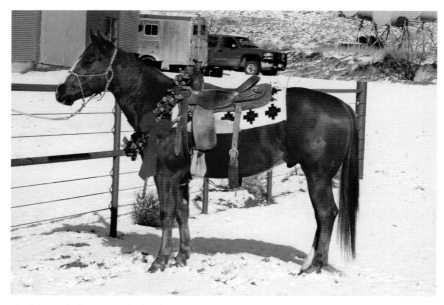

⋀ **Direct light.** Direct light shows more detail in the horse, as far as structure and muscling, than sidelight.

⋀ **Sidelight** is considered more creative. Your choice will depend upon your objective.

⋀ **Sidelight.** The strong sidelight that created this photo adds a three-dimensional feel to the subject and creates a peaceful, pastoral mood. From the direct light angle, this cute colt looked flat and uninteresting. This is also an example of fine-tuning your camera angle so that the subject stands out from the background. The light coming through the mane separates it from the background; the white mark on the face is strongly defined because it contrasts with the darker green shadow area, just as the dark part of the muzzle stands out from the light green area.

❮ **Midday light.** During the middle of the day, when the sun is overhead, it casts strong, unflattering shadows on the underside of the horse.

[29]

your own shadow. You want the horse's profile to be perpendicular to your own shadow.

General photo manuals often say that direct, front light is boring and makes your subject look flat, and for general pictures that can certainly be true. But if you want to specialize in classic conformation shots, then direct, front light is the most flattering and foolproof.

Recognizing direct, front light for the classic horse portrait is relatively easy, once you're aware. And anticipating the light patterns, in order to select a background, also becomes second nature.

At the risk of stating the obvious, in the morning, the western landscape is going to be your background. In the evening, the eastern landscape. That is yet another of the criteria for planning a horse's portraiture session.

But classic horse portraiture to record conformation is only one aspect of horse photography. You can take beautiful pictures that feature horses as the subject matter with light from any direction. On sunny days, sidelighting and backlighting can add a three-dimensional feel and create interesting highlights. Photographers refer to it as "sculpting with light."

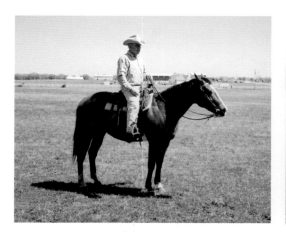

▲ **Same horse, different lighting.** One way to know where the sun was when the photo was taken is to notice the direction of the horse's shadow. The less flattering photo was taken when the midday sun was slightly behind her and to the right. In the second photo, notice the golden quality of the early morning light.

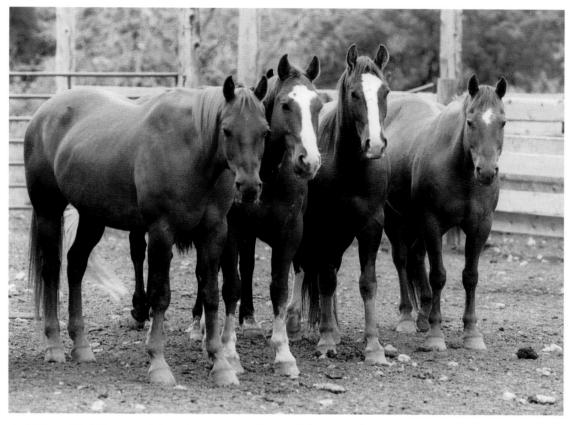

⋀ **Diffused light/overcast day.** On an overcast day, the light isn't as flattering to horses' coats, and colors aren't as vibrant. However, you have more latitude taking candid or unposed photographs, because you don't have to worry about stark shadows.

An overcast sky diffuses the light, reducing or eliminating shadows and highlights. Light colors reflect light and dark colors absorb it, so you'll notice that on overcast days or in low light conditions you'll see a lot more detail in a light-colored horse than a dark one. You'll also learn how the degree of cloudiness, or diffusion, affects your subjects. A high, thin scattering of clouds creates what photographers refer to as "hazy bright" light, enough to give you highlights and shadows and some of the benefits of directional light, but not as intense. Hazy bright light is good for taking portraits of people and horses together, because the contrast is still there, just reduced to a level that is more flattering to the human face.

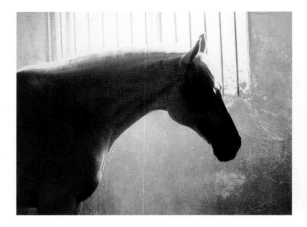 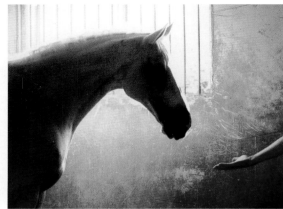

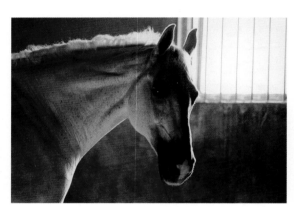 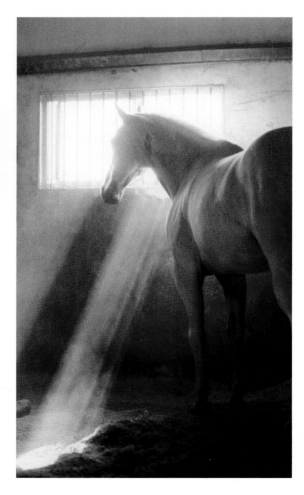

⋀ **Backlight.** These four photos were taken with two light sources—the sunlight streaming through the window and the more diffuse light in the aisle of the barn, with the back-light being the stronger of the two. I included all four so you could analyze how much difference the horse's position relative to those light sources made in the resulting exposures. If the horse had been a dark color, there would have been almost no detail in the shadow areas.

Thicker clouds eliminate shadows almost completely. This gives the photographer more latitude in selecting camera angles and the background. It doesn't matter if you shoot in the middle of the day when the sun is overhead, because it's so diffused.

On sunny days, the color and direction of the light is changing slowly but constantly, and what we consider the most ideal light lasts for just a brief time, not long after sunrise or before sunset. To get all the other elements of a good photo to come together within that window of opportunity is part of the challenge—you'll find that outdoor photographers are the types who like challenges.

Sometimes what couch potatoes deem the worst weather makes some of the best photos—not good for showing off conformation but aesthetically pleasing. That's partially because of the mood and because those type of pictures are more unique.

Because the sun and weather, while critical to the outcome of our photos, are beyond our control, we work around them by selecting the time of day and weather conditions in which we shoot. Early morning and late afternoon direct light is more golden, and more desirable, not just because of its color but also because of the direction.

Once you're aware of how the position of the sun influences the picture and how the horse's position relative to the sun influences how he looks in the picture, you'll be surprised that you never noticed it before.

With this greater awareness, you'll understand that a "good background" isn't a good background unless the lighting is right. Now you know why show photographers, even at outdoor shows, go inside a barn somewhere and set up a background and rely upon a powerful flash to illuminate their subjects. Show photographers' high-powered flash units will provide consistent results from hour to hour, day or night, cloudy or clear—consistently adequate. However, the consensus continues to be that the most beautiful horse portraits are taken outdoors.

Increase your awareness of these light patterns throughout the day, without a camera in your hand—not just the way light affects horses, but everything. As you become more aware, you won't have to consciously

∧ **Silhouette.** Silhouettes, a form of abstract art, are created when the only source of light is behind the subject. They are simple to take at sunrise, sunset, or in the alley-way of a barn. Just be sure as you're looking through your viewfinder that the sun is sufficiently obscured by the horse or some other photo element, so that it doesn't create lens flare. (Another warning: automated photo printers will tend to print silhouettes too light, trying to average out or get detail in your foreground. You want these prints underexposed so that the foreground goes black.)

think your way through the lighting aspect because it will just come naturally to you.

Outdoor photography gives you an appreciation of natural light—the subtle, incremental changes throughout the day and the way it affects the appearance of our surroundings. Once you start noticing light, it takes on a whole new dimension, and often you'll find yourself admiring the light as much as the objects it illuminates.

Action steps toward learning to see the light

To see light, observe shadows.

■

Analyze photographs in magazines or that you've already taken, and evaluate the direction and quality of the light when the picture was made.

■

Observe a loose horse moving around on his own, and specifically watch the way the patterns of light and shadow on his body change as he moves.

■

Walk around things and compare their appearance in direct light, sidelight, and backlight.

■

Pick out something you see often, like a tree or building, and make it your guidepost. Let the sight of it be your visual cue to observe light's effect, not just in a single day, but from day to day and season to season.

■

Notice how shadow patterns change in length and direction throughout the day, as well as throughout the year.

■

The model horse exercise in chapter 6 is an ideal way to compare lighting effects, but you don't have to use an animal. Any object will do, even a bottle or box. And you don't have to take pictures of it, you can just move it around and notice the way the changes in lighting change its appearance.

■

As you train yourself to see the differences in light, you'll hone your instincts for finding the best angles and backgrounds for your photos.

4

Camera Considerations

Learn your camera's limitations as well as its capabilities

MORE THAN ONCE SOMEONE HAS LOOKED AT MY CAMERA AND SAID something like, "Wul, if I had a camera like that, I could take good pitchers too"—which always reminds me of that bumper sticker, "Guns don't kill people. People kill people." I don't mean I want to kill the offender. I'm just trying to find an analogy that puts the camera in perspective. Cameras don't take pictures. People take pictures.

That's one reason I argued with the logical people who suggested this appear as the first chapter in the book: Cameras get enough credit as it is.

There was a more important reason, as well:

Technology is changing rapidly and there is already a big disparity among the wide array of cameras being used. It seemed more practical to focus on what's in front of the camera—the horse—and what's behind it—the photographer's eye—while encouraging you to consult any of the infinite resources available to help you with your specific camera and the technical aspects of photography.

Before you buy a camera, do some research to be sure you understand its limitations, which are not as well-documented by the manufacturer as

its capabilities. Compare ratings online and in publications like *Consumer Reports*. The personal service available in stores that specialize in photographic equipment is worth the price difference. They carry cameras in all price ranges and typically carry used cameras and lenses too. (New doesn't necessarily mean improved.)

There don't appear to be any big bargains or any particularly bogus deals in the world of cameras. The only real mistakes you can make will result from not knowing what you want or need in the first place, or not understanding what you're getting.

By the time you read this, the drawbacks of consumer digital cameras relevant to horse photography might have been resolved. (The biggest problem is shutter lag, explained on p. 41.) If not, and if you don't want to spend the money for a professional quality digital camera, you will probably get better results with traditional 35mm single-lens-reflex, or SLR.

No matter how much photographic technology changes, I predict this will still be true: Most people never read their camera owner's manual. Read your owner's manual. And then reread it. No matter what camera you are using, you will get better results if you understand how it works before you get a horse involved.

Comparing cameras

You can get decent horse pictures from any camera, as long as you stick with the classic profile. However, some cameras are only suited to taking the classic profile. (Specifically, point-and-shoot cameras with a fixed lens, as opposed to a zoom).

Some zoom lenses do not have enough telephoto magnification to get optimum head shots or three-quarter views. Most moderately-priced point-and-shoots will be taxed by the demands of action photography, unless conditions are close to ideal (outdoors, sufficient sunlight, and within range of the lens). And the shutter lag that currently plagues most consumer digital cameras is enough to make a preacher curse. You see, there's a reason why professionals spend as much as they do for high-end equipment.

The vast majority of cameras sold today are point-and-shoot cameras, as opposed to traditional 35mm single-lens-reflex cameras (more commonly called by the acronym SLRs). Generally speaking, point-and-shoot cameras are more fully automated, making them easier to use but giving you less control. They have fewer parts than an SLR, so they are smaller, which makes them easy to slip into a purse or pocket. They are also less expensive than SLRs.

Point-and-shoot cameras come in a wide array of prices and features. They range from the modest one-time-use cameras (also called disposable cameras) to expensive models with long telephoto zooms and a broad menu of features.

Professional horse photographers use 35mm SLR cameras with top-quality (read "expensive") telephoto lenses. SLRs also come in a wide array of prices and features. They allow you to use interchangeable lenses, which add to their flexibility, because there is also a wide array of lenses from which to choose. While new SLRs offer a host of automated features, they also allow you to override those features or to combine them in ways that give you more exact control of your results. For instance, you can select the shutter speed and it will automatically set the aperture, or vice versa (more on this in the next chapter).

The best advice on cameras: *"Read your instruction manual. Then reread it."*

⋀

The mirror in the SLR projects the same image into the viewfinder as will be recorded through the lens. With a point-and-shoot, the optical viewfinder above the lens shows you close to the same image, but not exactly. You might not notice unless you were used to the SLR, but it does affect carefully framed shots, which is why you might end up with tops of ears cut off, etc. Nor does the optical viewfinder convey depth of field or exposure.

An SLR will allow you to add a more powerful flash than those that are built into the camera. All flash units have a limited range, which should be described in the owner's manual. Professional quality flash units also provide you greater flexibility and control of the amount of light on your subject.

> **If you thought** the horse looked fine but your picture looks like this and you're using a digital camera, shutter lag is probably the culprit. If you're using a film camera, your timing is a little off.

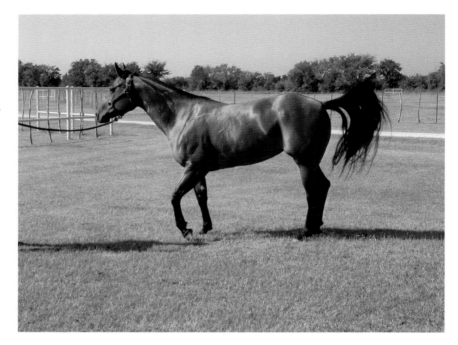

∧ **If you thought** the horse looked fine but your picture looks like this, digital shutter lag is probably the culprit again. You were moving on to the next shot before the camera captured the last one.

Point-and-shoot versus SLR is one choice; digital versus film is another. There are both digital and film point-and-shoot cameras and digital and film SLRs (there are more options beyond these, for that matter, but we're trying to keep this simple). Traditional film cameras capture an image by allowing light to pass through a lens onto film, which is coated with light-sensitive chemicals. Instead of film, digital cameras capture images by using light-sensitive computer chips.

At this time, the main drawback to taking horse pictures with the average consumer-level digital camera is one that seems to be often overlooked in the literature: it's called shutter lag. Pre-shutter lag means there is a slight delay between the time you press the shutter button and the time the camera actually captures the image. This can be a real problem when you're trying to capture the exact moment a horse puts his ears up and looks alert, or any type of action. Post-shutter lag is the time it takes

▽ **You can** get some great shots with inexpensive digital cameras, but low-resolution images become "pixelated" and blur when you enlarge them.

⋀ **In reality,** this horse's topline does not look like a ski slope and he has a normal-sized head. The lens on one-time-use cameras and point-and-shoot models with a fixed lens (doesn't zoom) will cause distortion like this, as will a zoom lens set to the wide-angle setting. Whatever is close to the lens will appear larger than what is further away, and the effect is more apparent the shorter the focal length of the lens.

for the camera to store the image in its memory, during which you can't take another picture. The amount of lag time varies among models. It is a real handicap, especially when taking action photos.

The resolution of the digital image determines how much flexibility you have in reproducing it. The higher the resolution, the larger it can be reproduced without losing quality. Also, be aware of the difference between an optical zoom lens and a digital zoom lens. An optical zoom lens

is a true zoom; it actually magnifies the subject. You will have the same resolution for a "zoomed in" image as for a wide-angle setting. A digital zoom has the same effect as cropping an image after you've taken it, which means it crops out the pixels around the edges and enlarges the ones in the center. The resulting photo will not be as sharp as one taken with the optical zoom.

My number one criterion for choosing a camera is lens quality—not just the focal length (degree of magnification), but the quality of the optics. High-quality, professional-grade lenses cost considerably more than consumer models, but add a dimension you can't get otherwise. The bigger you enlarge a photo, the more obvious the difference.

Comparing lens lengths

For *optimum* results in horse portraiture, the main feature you'll want is a lens with a focal length of at least 90mm.

How do you know what focal length your lens is? The information should be in your instruction manual.

However, my research on your behalf has made me aware that with point-and-shoot cameras, focal lengths often aren't documented or are documented in such a way that is confusing, especially with digital cameras. If you have a point-and-shoot camera with a fixed lens—in other words, it doesn't zoom in or out—it is probably roughly equal to a 30mm lens. In that case, you will get your best results taking the classic profile or scenic shots. Close-up head shots or three-quarter front or rear shots will appear too distorted.

The most important feature for an aspiring horse photographer is a telephoto lens.

If it does zoom in and out, it most likely zooms from a wide-angle setting to a telephoto setting. Typically, the maximum telephoto setting is about an 85–90mm equivalent. Some reach the 135mm equivalent range, and more expensive point-and-shoot cameras might reach 200mm equivalents.

If you could only own one lens and your goal was horse portraiture, an 80–200mm zoom would be a logical choice. It would allow you the

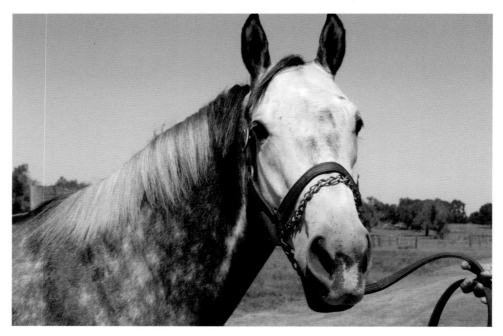

∧ **Wide-angle** (35mm focal length) lens setting

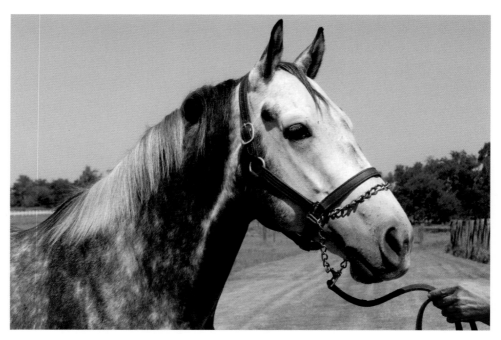

∧ **Normal** (50mm focal length) lens setting

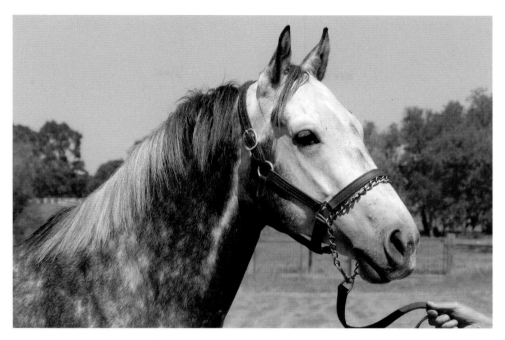

⌃ **Telephoto** (85mm focal length) lens setting

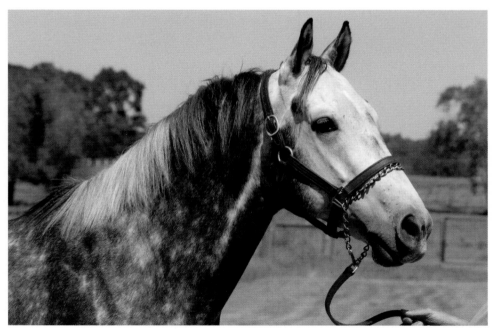

⌃ **Longer telephoto** (135mm focal length) lens setting

latitude to take profiles, three-quarter views, head shots, and staged action shots (where the photographer can get as close as the action permits.)

Rather than just try to tell you how the lens focal length affects the image, I'll show you with the pictures on the previous two pages. After you study them, the explanation might make more sense.

In 35mm photography,* the universal language of photography, a 50mm focal length lens produces an image close to what the human eye sees and is therefore called a "normal" lens. Lenses longer than 50mm are considered telephoto, because they magnify and compact the image, which is considered more flattering in portraiture, whether the subject is a champion horse or a cheerleader. Because of the dynamics of lens optics, a minimum 90mm focal length is suggested for portraiture, whether human or equine.

Wide-angle (anything less than 50mm) means that the lens is seeing a wider angle than the human eye would. It has a tendency to splay or spread out the image. The distortion is minimal in the center of the image, but becomes more distorted toward the edges.

Most people think the reason you use a long lens is because you can't get very close to your subject. That is one reason; however, in this application we use it to distort or compact the image in a way that is more flattering. For instance, if you go into a professional portrait studio, the photographer may have a wide array of lenses from which to choose, but he'll use a 90–120mm lens. Obviously he could get right up in your face if he wanted to—distance isn't a factor. He uses the longer lens because of the effect it has on the image.

A wide-angle lens has less distortion in the center of the image, with increasing amounts of distortion toward the edges. Let's say we're going to take a portrait of a horse using a wide-angle lens. Most people have the tendency to fill the frame with the horse. By filling the frame, I mean the horse covers most of the photo area. In a profile pose, his nose would be

*35mm photography refers to the size of the film used, while the focal length of the lens used in 35mm photography is measured by the distance from the film the lens must be positioned to focus a sharp image on the film.

To avoid distortion, keep the horse parallel to the film plane. In other words, stick with the profile. And don't get too close, because there is less distortion in the center of the frame, which becomes more pronounced at the edges. Remember, the image in the viewfinder is not exactly the image the lens sees. For the same reasons, to take head shots, don't fill the frame with his head. You can crop it later. You won't get good enlargements from really cheap cameras, but you can get good pictures. The automated exposure preset at the factory overexposes scenes in bright light, but the film has enough latitude to still render a decent print. If they look too washed out, ask the minilab to underexpose the negative to compensate and reprint it.

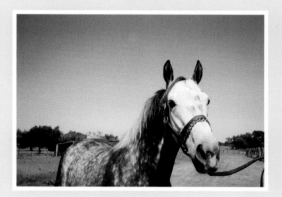

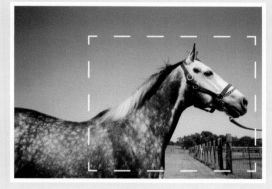

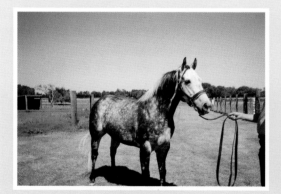

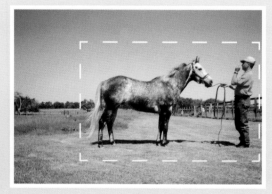

When using a one-time-use camera (or your cell phone camera) don't face the horse toward the camera.

The profile shot is more flattering. You can crop out the unwanted background later.

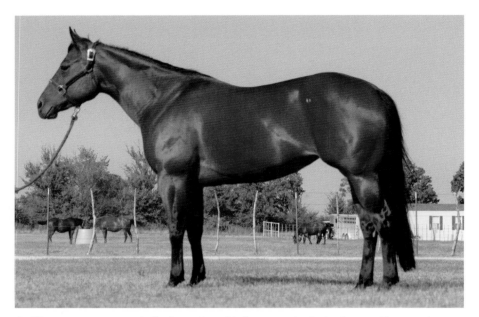

⌃ **The camera** automatically focused on the fence post in the background because it was in the center of the frame.

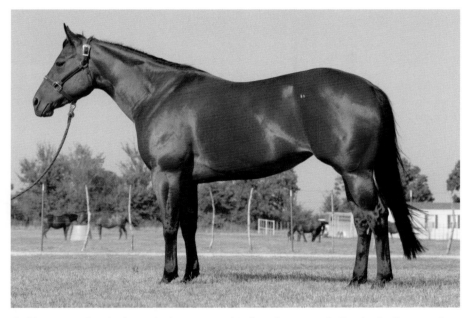

⌃ **To ensure** that the horse is sharp, center his front legs or underline in the frame and "lock focus" by pressing the shutter halfway down. Then reframe the shot and press down the rest of the way.

You can take the classic profile with any kind of camera, even a disposable, but if you are going to take three-quarter views or head shots, you really need a telephoto (or zoom) lens. If you are going to take action photos, you'll get better results if you have some kind of control over the exposure mode (in other words, an "action" mode which will adjust shutter speeds).

■

close to one edge and his tail on the other. By filling the frame with the horse's profile using this wide-angle lens, you are creating the most distortion on the horse's head and rear end. There are two solutions to this problem: use a different lens or camera, or if this isn't an option, move back so the horse doesn't fill up so much of the frame. In the finished print, you'll have some space around the horse that serves no purpose, so you get out your scissors and trim the photo closer to the horse. The result will be more flattering to the horse than if you'd filled the frame.

For head shots or three-quarter shots, a greater focal length is more flattering. Photographers who specialize in conformation shots usually use a 100- to 150mm focal length for three-quarter shots and a 200mm focal length for head shots.

Remember that the autofocus sensor focuses on the center of the frame, which is why the horse in the top photo is out of focus and the fence post in the distance is sharp. You can "lock focus" on whatever you want to be in focus, even if it isn't in the center of the frame. Simply center what you want to focus on in the frame momentarily and press halfway down on the shutter release, then reframe your picture in the viewfinder and press down the rest of the way.

5

Technical Trade-offs

Understanding exposure, ISOs, shutter speeds,
apertures, depth of field and why they matter

THE PROLIFERATION OF POINT-AND-SHOOT CAMERAS HAS MADE IT easy for people to bypass the technical aspects of photography, and most choose to. However, if you want to consistently get better pictures, at some point you will need some basics.

All this talk of ISOs, shutter speeds, apertures, etc., gets confusing, because the factors are all interrelated. What each one means and how it affects your horse photography will become more apparent to you when you take your own pictures. I suggest you reread this information as you gain experience. Eventually it will all make sense.

Photography literally means "writing with light." The camera uses light to transfer an image onto either film or light-sensitive computer chips. The more available light, the more the camera has to work with— another reason it's easier for any camera to take pictures outdoors on sunny days.

The amount of light that hits the film or image-sensor array is called the exposure. Too much exposure and the image is too light; too little exposure and it is too dark.

︿ **"Depth of field"** is the area of the scene, from front to back, that is in sharp focus. Here the camera was focused on the fence post in the foreground, so the horse in the background is "dropped" out of focus.

In the not-too-distant past, before camera functions were automated, you had to understand how to control the exposure in order to capture an image that could even be reproduced.

In a traditional film camera, exposure is controlled through a combination of the shutter speed, which controls the length of time light reaches the film (and therefore the amount) through the lens opening, called the aperture, and by the size of the aperture.

Shutter speeds and apertures work together in a teeter-totter relationship. You can get the same amount of light with a small opening that remains open longer as a large opening that is open less time.

If the shutter is open for more than a fraction of a second and there is any movement on the part of either the subject or the photographer, the movement will cause a blur in the image. So, the faster we need the shutter speed to open and close in order to freeze the image and get a sharp print, the larger aperture we need to get adequate exposure.

An adjustable diaphragm controls the size of the aperture (lens opening) and the size of the opening is called the f-stop. Logically, the larger the opening, the more light is let through. (What creates confusion is that larger aperture openings are indicated by small f-stop numbers—*f*4 is larger than *f*16—because the f-stop number indicates what fraction the diameter of a lens opening is in regard to the focal length of the lens.)

It is a property of lenses that as we increase the size of the aperture used for exposure, the "depth of field" decreases. Depth of field refers to the amount of the scene, from front to back, that is in acceptable focus. It is another reason that the classic profile shot is the easiest to take, because the profile of the horse requires a more shallow depth of field than if he were facing you at a three-quarter angle.

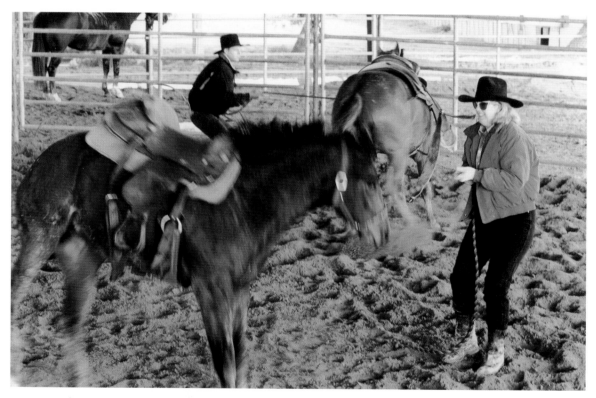

⋀ **The colt** is blurry because the shutter speed (1/60th of a second) was too slow to freeze his motion.

Shutter speeds and apertures work in a teeter-totter relationship. A relatively slow shutter and large aperture (1/50th @ ƒ16) produces a similar exposure as a fast shutter speed and small aperture (1/640th @ ƒ4.5), but notice the difference in the depth of field.

Aperture, shutter, and ISO settings are all divided up into comparable "stops," even though the numbering systems are different. For example, you can get the same exposure with a shutter speed at 1/60th of a second combined with an aperture of ƒ11 as you would with a shutter speed of 1/500th of a second combined with an aperture of ƒ4 (remember, smaller f-number = larger opening).

⋀ **1/640th @ ƒ4.5**—fast shutter, large aperture

⋀ **1/50th @ ƒ16**—relatively slow shutter, small aperture

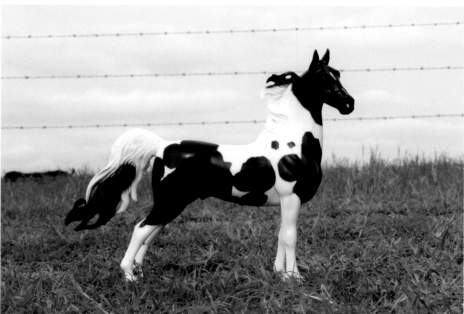

⋀ **Depth of field** is related to aperture. The photo above was shot at *f*2.8, creating minimal depth of field and blurring the barbed wire fence in the background into oblivion. The photo below, with the greater depth of field, was shot at *f*29.

In addition to the aperture, two other factors affect the depth of field: the focal length of the lens (change to a shorter focal length lens if you need more depth of field) and the subject distance (move away from the subject to increase depth of field.)

◀ **This picture,** shot with Velvia slide film, rated at ISO 50, has much less contrast and much greater color saturation.

◀ This image was shot on ISO 400 film, which is three times more sensitive than the ISO 50 slide film used for the comparison shot. ISO 400 allows a faster shutter speed—good for action, but resulting in a grainier image. This print was also overexposed to show detail in the dark areas. The trade-off for the higher contrast and over-exposure is in color saturation.

Compare the same pose taken from approximately the same spot with the disposable camera and the 35mm digital SLR. Disposable cameras are preset to expose 400 ISO 35mm film at 1/125th shutter speed at ƒ10, and the lens focal length is typically 30mm. The comparison print was shot in shutter priority mode at 1/250th, and the light meter set the aperture at ƒ13, with an ISO setting of 250, with a lens focal length of 42mm—still wide-angle, but look at the degree to which the background and foreground were compressed compared to the 30mm lens. Both pictures were cropped from larger images because of concern about distortion at the edges of the frame when using the disposable camera.

ISO numbers relate to light-sensitivity whether in film or digital photography. For horse photography, shutter speed is generally a greater priority than depth of field. Higher numbers are more light sensitive and don't require as much exposure to record an image. However, the trade-off for greater light sensitivity is a "grainier" image.

The best way to explain the technical aspects of photography is "Everything is a trade-off." Every time you change one thing, it affects something else.

The 1:2 Ratio

Traditional shutter speed settings are in a geometric progression related by a 1:2 ratio to simplify manual calculations.

Shutter speeds:
30 (1/30th) 60 (1/60th) 125 (1/125th) 250 (1/250th) 500 (1/500th)

Though the numbers are getting larger, they represent the fraction of a second—length of time—that the lens aperture (opening) is open. So, although the numbers appear to be getting larger with each increment, light is entering the camera for a shorter amount of time with each increment.

Greater number =
faster shutter speed =
greater ability to freeze action

Aperture settings also reflect a 1:2 relationship:

2.8 5.6 11 22
　4　　8　　16　　32

The aperture number is related to the size of the opening relative to the length of the lens.
The aperture controls the "depth of field."

Greater number = smaller aperture (lens opening) = greater depth of field

Standard ISOs, you'll note, also have a 1:2 relationship

100 200 400 800

Greater number = more light sensitive = not as sharp when enlarged.

When you are shooting action or in low light situations, a higher ISO allows you to use a faster shutter speed to get the same amount of light as a slower shutter speed at a lower ISO.

Digital cameras operate somewhat differently, although the exposure is still dependent on the amount of light the camera captures. According to *Digital Photography for Dummies*, 3rd edition, some consumer-level digital cameras don't use a traditional shutter/aperture arrangement to control exposure. Rather, the chips in the image-sensor array simply turn on and off for different periods of time, to capture more or less light. Again, that's why I encourage you to read and reread your owner's manual and consult timely resources to learn more about your particular camera. Digital cameras' capabilities are usually translated into film-camera terms.

Being able to adjust the way in which the camera achieves the exposure is referred to as "creative control," because it allows you to do more than capture a printable image. You get to predetermine if you stop action or if the galloping horse's legs will appear as a blur. You can decide to drop the background out of focus to allow the horse to stand out more. This is when you really start to feel like a photographer. Just as there is a difference between really riding a horse and merely sitting upon one, there is a difference between creating portraits and taking snapshots.

6

The Model Horse Exercise

The fastest, easiest way to learn the basics of horse photography

A LOT OF VARIABLES AFFECT THE WAY A HORSE LOOKS IN A PHOTO-graph, and while you're learning how to juggle them, it helps if your subject is portable and made of plastic. Even if you have easy access to a real horse, using the model horse is the fastest, easiest way to learn.

It removes much of the inherent challenge in photographing a horse and slows things down so you can concentrate on what *you* are doing without having to factor in what the horse is doing. This way, you focus on your camera, then the light and shadows, then the background.

As you will learn soon enough, horses (and people) have an optimum time span during which you can get a good picture. That's why it's important for you as the photographer to be comfortable with what you're doing before you get the real live horse in front of you, rather than fumbling around, trying to figure out how to set your camera and where to place the horse in the best light.

You can substitute a trophy or a sculpture, or even a rocking horse. And it doesn't have to be a horse. It could be a bull, dog, elk, or anything else with four legs.

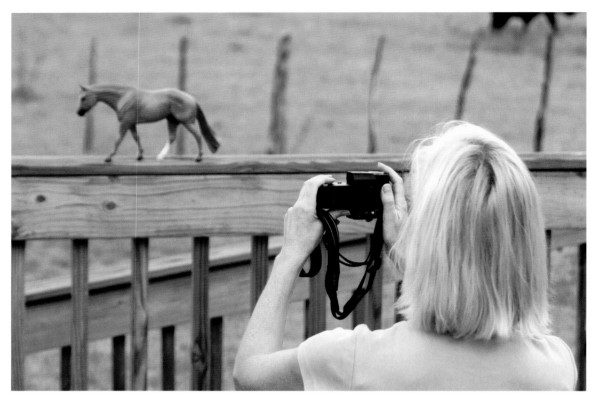

▲ **You'll be** more efficient taking photographs of horses if you practice with something that doesn't move. It gives you an opportunity to experiment with your camera, to shoot in something other than "program" mode.

It also helps that most of these portable, plastic models are already stuck in a charismatic pose. Whatever their pose, they will maintain it long enough to analyze from every angle. For that matter, you have time to print your photos, analyze what you might have done differently, and reshoot the same pose. Again and again. Until you're pleased with the results.

Yes, it sounds hokey, and in reality most people are never going to do the model horse exercise. Still, I'm including it here because I have seen how much my students benefit from it, despite any initial lack of enthusiasm. They become more enthusiastic as they see the results, and the big difference *they* make, through their choices in lighting, background, etc.

⌃ **Even with** model horses, photo shoots don't always go as planned. Try to laugh if the breeze tips your horse over or an extra animal walks into the frame. It's good preparation for what's ahead.

People are often surprised at the way their pictures look, compared to what they recall seeing when they took the picture. With practice, your awareness level will increase. You will begin to associate what you are seeing through the viewfinder with the finished picture. The model horse, because it is always available and always in the same pose, allows you to go back and compare your pictures to your model, therefore helping you learn how the camera renders images differently than your eyes.

It's simple, really. Just go outside and take pictures of a model horse, the way you would a real horse. For better results, first familiarize yourself with the Simple Recipe and the information in the chapters on seeing the light and finding flattering angles.

▲ **Unlike a live model,** this horse maintains his pose long enough for you to notice the lighting and background.

First, concentrate on the lighting.

Look at the position of the sun and its effect on the shadows. Move the horse around until the shadow falls directly behind him. Just so you can see it for yourself, take some pictures of him in this light, then in sidelight, then backlit. Place the horse in the shade, and compare the effect.

Often, even when people understand the concept and shoot accordingly, they discover when they look at the resulting photograph that the camera saw it differently than they anticipated. The effect seems clearer to people when they take the picture themselves, rather than being shown the effect when someone else does it.

Next, concentrate on the pose.

Figure out where you need to be in relation to the horse to capture the best pose. Take as much time as you need to move around and see how the relationship of his feet changes as you move.

Because model horses come in a variety of poses, some are more suitable to the classic profile. Regardless of how their feet are permanently placed, you'll notice some angles are better than others.

Finally, look carefully at the background.

See how the background changes as you look at your subject from different angles.

Print and analyze the results.

After you've taken a few shots with different lighting, poses, and backgrounds, print them and analyze the photos as a group. Really study them. Compare them to each other. Compare them to other pictures you like. What's different? What's similar? How would you change the pictures you took? What do you like most about them?

▲ **Distortion from** shooting with a wide-angle lens at close range is obvious even with a model horse.

▲ **You'll understand** depth of field better after your own experimentation.

Round 2

Even if you liked every single shot in your first set of pictures, do the exercise with the model once more. Try something different this time. *Experiment.*

This time, if you are shooting digital, resist the urge to look at each shot as you take it. Wait until you are through with this part of the exercise, and look at them as a group. Then repeat your analysis. Compare this set with the first set. If there's a problem you still can't identify or solve by comparing it to examples in this book, show them to someone who can help you—the people who work at professional photo labs or camera stores are usually knowledgeable and generous with their help, especially if you're a customer.

Now, you're really ready to take horse pictures! All the kinks have been worked out without having to involve another creature, human or equine.

7

Scouting Locations

Background is only one consideration

WHEN DECIDING WHERE TO TAKE PICTURES, PEOPLE GENERALLY start and end their search by analyzing what is going to be in the background. That's not enough! Several other factors affect the photo session and the end results.

This chapter is specifically about how to select the best place to take pictures when someone is posing the horse with the help of a halter or bridle, but it also applies to taking pictures of loose horses in a pasture or pen.

Scout for locations and make any adjustments *before* you get a horse or handler involved. You don't want their good attitude and your good light waning while you weed-eat.

There's rarely an ideal location, but in your search, you'll want to assess the following considerations.

1. Light source
2. Slope

⋀ **The perfect location** in the morning won't work in the afternoon because the sun has moved—well, the sun hasn't moved, but it sounds funny to say the location no longer works because the earth moved.

3. Is there sufficient space?
 a. Between the photographer, using a telephoto lens setting, and the horse
 b. Between the horse and background elements like a fence or barn
 c. For the horse to pose in more than one spot with appropriate background
4. Background
 a. Visual distractions (cars on highway, dumpsters, junk pile)
 b. Scale (how does the size of the horse compare with things in the background?)
 c. Contrast (does the horse visually stand out from the background?)
5. Where will the horse naturally want to look?
6. Is the grass relatively short and even?
7. Does it matter which side of the horse you photograph?

Light

My first consideration in choosing locations for traditional, posed conformation shots is the direction of the available light at the time we plan to take pictures. (Although sometimes we decide whether to take pictures in the morning or afternoon based on which would provide us the best location—everything is a trade-off).

A lot of good backgrounds or perfect slopes are automatically ruled out because they aren't compatible with the direction of the sun. Plan to shoot toward the west in the morning and to the east in the afternoon.

One of the most common mistakes I see people make is selecting a beautiful background and being so set on using it that they take the picture there without considering the direction of the sun and therefore end up with some horrific shadows.

Review chapter 3 if you're unsure of how the direction or availability of light affects your subject.

⋀ **A common mistake** is selecting a location based on the background without first taking into consideration how it relates to the direction of the sun, which is why this horse's profile is distorted by shadows.

Slope

Ground is seldom level. You'll become much more aware of this fact when you start taking pictures. We don't want the horse going downhill, even slightly. You never want them to appear taller at the croup than at the withers. A gentle uphill slope is ideal.

Obviously, the easiest way to turn a downhill slope into an uphill slope is to turn the horse around. However, doing so might mean a compromise somewhere else, like with the background, where the horse naturally wants to look, and whether or not you're getting the mane side.

Even what appears to be a smooth slope often has low and high spots in it that you won't anticipate until the horse is actually posing. Since we

prefer the horse to be heading slightly uphill, we don't mind if his front feet are on a high spot, as long as his back feet aren't in a hollowed-out low spot—in other words, as long as you can still see all his feet. If his hind feet appear to be in a hole or on a high spot, just walk him forward into another pose.

It's better also when the ground between the photographer and the horse is fairly level or slopes uphill toward the horse. The uphill slope is acceptable because you were planning on kneeling to lower your camera angle anyway. To compensate for an obvious downhill slope, keep lowering your camera angle. You might end up lying on the ground.

Is there sufficient space?

As mentioned earlier, one of the common mistakes most people make is getting too close to the horse when taking its picture. Usually this isn't a space issue so much as a misunderstanding about lens dynamics. But sometimes it is a space issue, especially on small suburban "ranchettes" or at shows where trucks, trailers, traffic, and other obstructions create challenges.

You need enough space to see all of the horse in the viewfinder using a telephoto setting on the lens, with the horse standing far enough from anything in the background, like a wall or fence, to not cast a shadow on it.

You also need a space wide enough that the horse has sort of a runway or stage in front of the photographer, so he can walk straight into a

∧ **Slightly downhill.**

∧ **Level.**

∧ **Slightly uphill.** A slight uphill slope is more flattering in a profile shot. A downhill slope should be avoided.

> **Because the** horse is so close to the barn, it's hard to distinguish his head from his shadow.

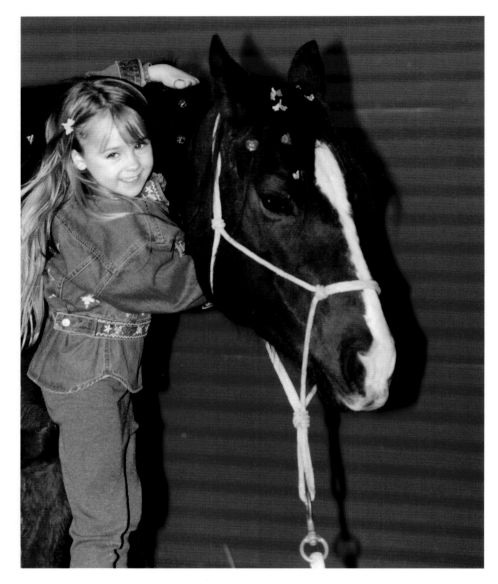

natural pose. You can't just plant him in front of you like the model horse. And since he probably won't stop perfectly the first time, you need enough room to keep walking him forward.

As you visualize this stage, look at the background. Is there enough acceptable background for the horse to stop in more than one place?

Or must he stop in a very specific place in order for this background to work?

Background

Generally, we prefer plain backgrounds for horse portraiture, so nothing draws attention from the horse. Think of the backdrops used for yearbook pictures or in professional portrait studios. With the entire outdoors as our studio, blue sky or dense woods often make the simplest backgrounds.

To evaluate a potential background, look through the viewfinder and visualize where the horse will be. Then kneel down low like you would if you were taking the picture. Sometimes something in the background makes you think it won't work (like some scattered trees or an outbuilding), but when you look through the viewfinder from the angle at which you are going to be shooting, it appears diminished or the horse covers it up.

Your subject needs to stand out from the background, physically. You want his shadow to fall on the ground. If he's too close to a wall, fence, or shrubbery, his shadow will fall on them, rather than on the ground. The shadow will be so obvious in the photo that it detracts from the horse.

Barns, silos, or trees in the background become less objectionable the further away they are. If the horse is standing right in front of a truck, trailer, or barn, the horse looks small and less majestic by comparison.

You usually want the horse to visually stand out from the background, as well. The exception would be if you were trying to camouflage a less-desirable trait.

A dark colored horse in front of dense green foliage doesn't provide enough contrast for him to pop out of the background. It's like a camouflage effect. It's not going to make a striking portrait of the horse if his coat color and the background are of similar values. That doesn't mean similar colors. We obviously know that the horse is not forest green, but he is dark. Similarly, if you have a light gray horse, a clear blue sky won't provide much contrast.

⋀ **To evaluate** a location, kneel down low to see it from the angle you'll be taking the picture, because the background will look different. Notice how the building in photo A is diminished when seen from the lower angle in photo B. Also notice how much larger the horse appears from the lower angle.

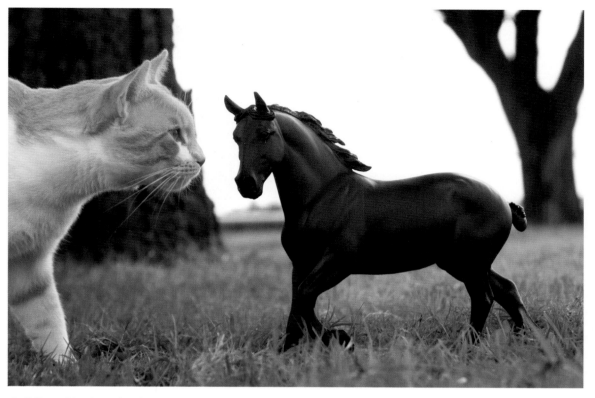

⋀ **Other objects** in the photograph serve as a visual measuring stick. For conformation shots, the horse should dominate everything else in scale.

Creating contrast is part of the reason shooting Paint horses can be such a challenge. It's hard to find a neutral background where their entire profile is delineated. These are subtle optical illusions. The person who is looking at the photograph doesn't say, "The reason this Paint looks like he has no muscling in his hindquarters is because the white patch on his hip is blending in with the white clouds in the background." They just look at the picture and think, "He doesn't have much of a hip on him."

Strong contrast is like shining a spotlight on the horse's lines. There-fore, if you have a horse that might have what are considered structural flaws or a lot of age on him—if, for instance, he was swaybacked or over at the knees—he might benefit from a background in the same tonal range.

∧ **The color** of the horse will influence your choice of backgrounds. Compare how the darker horses blend in and the lighter ones stand out.

Where is the horse naturally going to want to look?

Realizing the answer to this question can make the photo session easier for everyone involved. Where will the horse naturally want to look? Generally, he wants to look at the barn or wherever there are other horses or activity.

Some horses will be inclined to turn their whole body around and see what's going on behind them. Others won't make an issue of it, but they will keep pointing their ears back in that direction.

If the spot you're considering just happens to have the right light, slope, background, etc. *and* the horse can face the barn, great! If not, you can get around this problem much more easily than the other considerations, by creating diversions of your own. (See "Getting Ears" in chapter 9.)

Where the horse naturally wants to look won't be your highest selection criteria, but it's worth keeping in mind. And remember that all horses are individuals. Sometimes, if you aren't getting the pose you want—either the horse is too dull or too anxious—you'd be surprised at how much better they do when you simply let them face the other direction.

Will tall grass or weeds be a problem?

The area where the horse stands doesn't need to be manicured like a golf course, but tall grass is a problem. If you can't see the feet or pasterns, no one can use the photo to evaluate the horse's conformation. (Of course, if you are photographing a horse with bad feet, this is one way to camouflage the problem.) Tall grass also creates an optical illusion of imbalance, because you will see the horse as being longer-bodied and shorter-legged instead of an accurate portrayal of this horse's true body.

The same thing can happen when the grass is uneven or has clumps of weeds. If it covers the horse's front feet but not the back, or vice versa, he'll look unbalanced.

Compared to the other factors, this problem is relatively easy to fix without having to sacrifice anything but some mower time.

If you mow the grass, mow an area broad and deep enough that the horse has room to pose. Allow some leeway. And, rather than just mowing a strip for the horse to stand on, mow the area between the horse and photographer so there won't be any distractions in the foreground.

Does it matter which side of the horse you photograph?

In general, I would shoot whichever side of the horse corresponded with the uphill slope with the best background in the light I had available. However, sometimes horse owners will have a preference. Perhaps they really want the mane side, or perhaps they really *don't* if there's a chunk missing. Sometimes they'll insist on shooting the brand side, if it's their brand, or not shooting the brand side if it isn't.

This is the third factor that will help you decide which way the horse should face. The other two directional considerations are slope and where the horse is naturally going to look. There's sometimes a fourth factor: the wind. Like the sun, it is a variable you can't control, but one you can work around. If the sun is setting in the west and the wind is blowing from the south, you don't want the horse facing north or his tail will blow up between his legs. On the flip-side, if a gale is coming from the opposite

> **One strategy** for taking candid photos is to find a place with pleasing lighting and background and then wait for a horse to come into the frame.

direction, his tail might look dramatic flowing out behind him, but he isn't going to want to put his ears up and keep them there.

If a wind-blown mane becomes too distracting, it can be braided to keep it down. You might try wetting it, but don't get the photo side of the neck wet. A couple of times, in a pinch, we've just divided the mane in sections and loosely banded it with a washer attached to the rubber band to weigh it down. Primitive, but effective.

Besides the flying hair, strong wind tends to make horses—and people—a little more difficult to work with, a little testy. If you can, try to reschedule for a more pleasant day.

8

Grooming Considerations

for a Photo Shoot

Don't forget the fly spray!

MUCH OF THE SUCCESS OF A POSED PORTRAIT DEPENDS ON thinking about a few things in advance, and grooming is one of those considerations.

Photographers generally don't get involved in the grooming process, but if you can influence these considerations, it can have a positive effect both on the photo shoot and the finished pictures.

In this context, we are talking about how grooming objectively affects the photo shoot and the appearance of the photograph, not specifically how it affects the appearance of the horse.

From a photographer's perspective, grooming serves two purposes: to fix anything that might be distracting in the finished print and to enhance the horse's hair for maximum shine, to reflect light and create more highlights. This makes the photo seem more three-dimensional rather than flat, which is especially important when we're shooting the flat side of the horse (the profile).

▲ **Flies love** photo ops like ants love picnics. Although photographers don't generally get involved in the grooming process, fly spray is an important consideration from the photographer's perspective, and it can add extra shine to the horse's coat.

Removing Distractions

Flies are a literal distraction. It's hard to shoot a moving target, and as long as flies are bothering your subject, the horse will be moving some part of his body. Any photographer needs an incredible sense of timing to make a swishing tail look otherwise in a photo.

The need to keep this distraction in check might seem obvious, but in my experience a lot of photo shoots have been held up while someone goes in search of fly spray. Spray the horse before you begin, but also have it handy in case you need to reapply. You never realize how quickly fly spray wears off until you're in the middle of a photo shoot.

Visual distractions are much more annoying after the photo shoot, when you're looking at your prints.

⋀ **We usually** don't notice the way a halter fits as long as it stays on the horse, but in a photograph we need to be sure it doesn't create a distraction. The plume that appears to be coming out of this horse's mouth is part of the halter.

[85]

⋀ **Banding a mane** is a tedious but effective way to ensure it lies flat. Applying appropriate hair products, wetting the mane, or wetting it and applying a mane "tamer" until it dries will also work.

Most of us rarely give much thought about how a halter fits if it stays on the horse at all, but a poor-fitting halter can come back to haunt you in the finished picture. Then, you can hardly see anything else. I prefer very plain halters, for the same reason, but that's a personal preference. Multi-colored or silver-laden equipment competes with the horse for attention. On the other hand, they can make a very showy impression.

Obviously the horse doesn't care how he looks, but he may become annoyed by the grooming session if it is more than he is used to. If you are going to do extensive bathing, clipping, or mane-pulling, do it a day or two in advance of the shoot. Don't use up the horse's good humor with extensive grooming right before you take his picture. You want him to be mentally fresh for the photo shoot.

Most everyone is conscious of unkempt bridle paths when the hair sticks straight up. What might be less noticeable is a mane that does not lay flat (in fact most don't unless they have been trained to). The result is the horse's neck looks thicker than it actually is, which might be undesirable in a conformation shot.

The solution? You can wet the mane and apply a "mane tamer" or hood until the hair dries, or place a wet towel over the mane. You might want to apply a grooming product, like hair gel, if you choose this route. Or someone can band the mane. However, banding a mane neatly and evenly enough that you can shoot the mane side in the photo takes patience and skill. If it doesn't look right it can create as much distraction as the problem you were trying to prevent.

Enhancing the Coat

Horsemen appreciate a shiny hair coat because it implies robust health. Photographers appreciate shiny hair because it reflects light. The increased contrast due to the shine enhances muscle definition and gives the horse a more three-dimensional appearance in photographs.

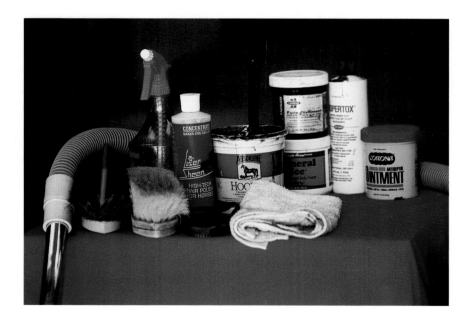

◁ **The rubber curry,** brushes, and soft rag are the key ingredients, although professional groomers have more in their arsenal.

> **Shiny hair** reflects more light, enhances muscle definition, and gives the horse a more three-dimensional appearance in photographs.

< For extra shine, baby oil was applied to this filly's clean muzzle and around her eyes. If the horse is the type that the handlers prefer to have carefully clipped, encourage them to do it the day before to preserve the horse's patience for the photo shoot.

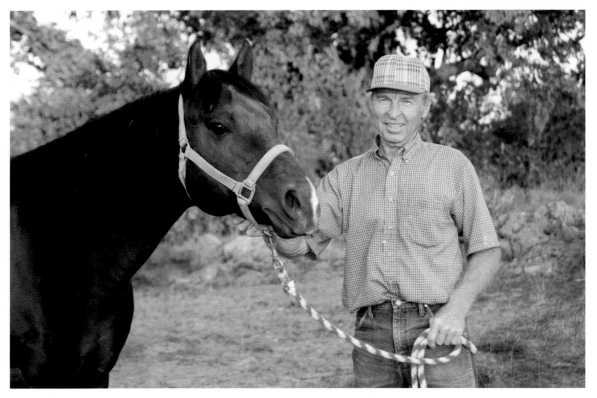

⌃ **Seize good** photo opportunities regardless of whether the horse has been brushed, polished, or has on his Sunday tack. Too many horses pass in and out of our lives without a visual record because we want to wait until we have them groomed better.

A perfect hair coat requires almost obsessive and constant attention on a daily basis. But even dull or sun-bleached hair will look better with the right kind of brushing and perhaps a little boost from a product like Laser Sheen™. The oil in fly spray also adds to the horse's shine.

Most people don't realize the huge difference that the right tools and technique make in the grooming process. It isn't just "elbow grease."

First, curry the horse with a round, rubber curry comb in circular motion to bring dirt and dead skin cells to the surface. Then, use a stiff brush to remove this debris. Finally, go back with a soft finishing brush for maximum shine.

Use softer brushes specially designed for use on the face or wipe the face with a soft rag to remove dirt and dead hair. It's easy to overlook brushing the face, especially since a lot of horses don't crave that kind of attention. Use a damp rag to clean the nostrils.

Some people apply baby oil to the horse's muzzle to make it shiny. They may even apply the oil around the eyes and inside freshly clipped ears. This technique should be used with a light touch if it is to look natural.

Laser Sheen™ and similar shine-enhancing conditioners are applied while the coat is wet. Laser Sheen's silicone properties reflect light and purportedly repel dust. If the horse is bathed, it's important to use a mild shampoo that doesn't dry the coat.

Of course, grooms use many other products, tools, and techniques to glamorize a horse's appearance. Different breeds and disciplines have different standards, as do individual horsemen. The way a horse is groomed, and the extent to which it is groomed, really isn't the photographer's decision. However, if you're photographing a horse for someone who doesn't make grooming a priority, you might just ask, "Do you want to brush out his mane and tail before we take pictures?" Clean coats and untangled manes and tails seem to have universal appeal.

Seize good photo opportunities regardless of whether the horse has been brushed, polished, or has on his Sunday tack. Good horsemen can see beyond grooming, and the people who care about the horse see beyond it too. Too many horses pass in and out of people's lives without a visual record because the owners wanted to wait to take pictures until the horse "looked better."

9

Setting Up Photo Opportunities

How horse sense and people skills make you a better photographer;
plus how to set up a posed horse portrait

AS YOU EVOLVE INTO A PHOTOGRAPHER, YOU LEARN TO RECOGNIZE photo opportunities and how to make the most of them. But if you passively wait for those opportunities, you won't get many great pictures.

Creating better photo opportunities requires horse sense and people skills.

Most of the pictures you see in horse magazines were taken with the help of at least one person besides the photographer. When helpers are good at their jobs, the photographer looks like a genius.

It obviously helps if they've got horse sense too, but regardless of how savvy they are about horses, you can't expect them to know what makes a good picture. Also remember the view looks different depending upon your perspective—the view from their angle is different from what you as the photographer are seeing.

When you arrange for the photo session, explain the best time to take pictures and why (because of the light), so that the horse's human connections know that you aren't just cramming them into your busy schedule, but that everyone is fitting into the earth's rotation schedule. Be sure they have enough time available to help you.

For horse portraiture, I prefer to have no more than two helpers—one to set up the horse and one to "get ears." More people typically distract from the effort. Even if they don't distract the horse, onlookers may cause the handler or "ear person" to feel self-conscious.

<< **Most horse portraits** published in advertisements were taken with the help of at least one person besides the photographer.

However, if there are extra people around, I make a point to speak to them and let them know what we're doing and how they can help. (Generally that is to be quiet and keep still unless called upon. If you have more than one horse to photograph, ask if the extra person can get the next

horse ready while you and the helpers photograph the subject at hand, so you don't have to waste any precious light.)

People are always asking me how long it takes to photograph a horse. Well, it takes just a fraction of a second. But setting the scene and getting the right pose in order to take a good picture can be time consuming.

This is one reason your helpers need to be aware in advance that this could take three minutes or thirty minutes. The irony is if you have time to spend and everyone is relaxed, the photo session usually goes quicker (or maybe it just seems like it does).

Ask in advance about the barn's feeding schedule, to make sure it doesn't conflict with having the horse ready for the ideal light. If the horse is accustomed to being fed at a certain time, he'll become harder to manage the longer he's missing his regular meal. Impress upon everyone to hold off feeding any horses in the area while you're taking pictures—your subject will obsess about not getting his share.

Even if the helpers are your best friends, if you haven't taken pictures together before, be sure to explain what you plan to do and what you expect of them. Once they know what is expected, the anxiety level decreases.

Explain to them why you've picked the location that you have. Define the range of area in which you'd like the horse to pose. Show them the shadows and how they affect the horse, so everyone will understand why the horse needs to be in a certain position. If your helpers don't have a lot of experience taking horse pictures, you may want to show them a sample photo to give them an idea of the pose you are hoping to get.

Once the session begins, remember that the pose looks different depending on the perspective of the person looking at it. The arrangement of the horse's feet looks a lot different from the viewpoint of the person holding the horse than from the photographer's view. Make everyone aware the moment the horse has stopped like you want; don't assume they will know.

If the horse is haltered, ask the handler to keep walking the horse forward and allowing the horse to stop on his own until he stops with the

back feet in position and only one front foot needing to be adjusted to get a nice pose. If the handler stops the horse with the lead rope, instead of letting the horse stop on his own, the horse typically stops midstride and out of position.

If the handler knows in advance that this may require several repetitions of letting the horse walk and stop, walk and stop, running out of good background and circling around to repeat the process, he won't be embarrassed or frustrated when it happens.

Most people who have spent time around animals know that when people are tense, the animals pick up on it. You want everyone to be relaxed, yet working efficiently.

One of the best ways for you to learn how to communicate with your helpers is do their jobs yourself a few times. It's much easier to stand on the sidelines and say "Move the left front foot three inches," than it is to actually get the horse to place his foot in the proper position. Some horses overreact while others don't react at all. When you ask someone to move the horse's feet, be very specific about which foot needs to be moved and how much it needs to be moved. And try to maintain your sense of humor if it doesn't work out that way.

Ask the handler to wait for your direction for what needs to be moved once the horse has stopped. Sometimes the horse will move independently, and the handler rushes to correct him, when the horse might be posed better after the move. Often when the horse moves on his own, he puts an awkwardly placed foot into a more comfortable and balanced position.

A handler that can anticipate a horse's movement before he actually moves is invaluable. If you're tuned into the horse and sense he is about to move, it usually takes very little movement from the handler to cue him to stay in place, maybe just raising the lead rope enough so the horse feels a touch of pressure. A common mistake is waiting until the horse has moved and then overcorrecting him.

The lead rope looks better if it doesn't interfere with the horse's face. Ask the handler to hold the lead rope so it isn't distracting. Even if you

⌃ **When you ask** helpers to move the horse, be specific, and be patient. It's much easier to say "Move the front foot on the far side up two inches," than it is to actually get that response from the horse.

plan to use computer software to take out the lead rope in the final picture, touch-up will be easier if the rope doesn't cross the horse's face.

Just because someone is experienced in handling horses doesn't mean the person has the patience for a photo shoot. How you handle the situation can make the difference. If you think the handler is about to have a meltdown or lose his temper, come up with a reason to take a break. Say

you need to change batteries or something and let the tension ease before resuming the session. Helpers will be more cooperative when they understand why things are being done a certain way. Show your appreciation early and often.

How to set feet

Horses are more comfortable maintaining a pose when they've stopped naturally than if you set each of their feet. The longer they keep their feet in place, the more time you have to evaluate and take more than one shot, to look for more flattering angles or get a more charismatic expression.

The classic profile pose is very similar to a horse's natural stance, which is yet another reason it typically yields the best results.

The best way to "set feet" is to let the horse do most of it and then fine-tune the front feet if necessary.

When taking a posed portrait of a horse that is haltered, people often try to set each foot in an attempt to duplicate the pose they see in magazines. Rather than lining the horse up for the sun and then trying to move each foot, just have the handler walk the horse into the area where you want him to pose and let the horse stop naturally. Keep doing this until he stops with his back feet in the correct position for the photo. Usually his front feet will be close to the correct position, although one foot might have to be adjusted to improve the pose.

For a profile pose, don't try to stop the horse abruptly, because that usually causes him to stop in midstride. But when you want to set him up square, for a three-quarter view, you might want him to stop more abruptly and get his feet under him.

Either the handler or the designated "ear person" (see next page) can move the feet into position. Sometimes, depending on the situation, I will do it myself. If you are taking three-quarter views—which might require adjusting the hind feet—and the horse won't stay in place unless the handler is at his head, the photographer or "ear person" should assist. It all depends on the personalities of the people and horse involved and how they work best together.

Getting ears

One of the terms unique to livestock photography is "getting ears."

The ears are a horse's most obvious expressive feature. Horses are considered more photogenic with their ears pointed forward, indicating that they are alert and interested.

Although we refer to it as getting ears, the position of the horse's entire head will be influenced by where he is focusing his attention. When he locks in on another person, horse, or object, you can get him to raise or lower his head and tilt it in any direction. This is hard for the photographer to control from behind the camera. Therefore we always prefer to have a designated ear person.

You'd prefer an uninhibited person (the class clown is ideal) because some horses require extreme measures to get their attention, especially if there is a lot of other activity going on or you are asking them to face away from their barn.

Before you get the horse in position, stress to the ear person how short the horse's attention span is and that it is imperative that everything else be in place before he or she tries to get the horse's attention.

Photographers and their helpers have used all types of gizmos and movement to get ears because the same technique does not work on every horse. First, check out what else is competing for the horse's attention. Are there other horses nearby? People driving cars in and out? Dogs?

Once you know the competition, you can plan your strategy and timing. There's a long list of props, noises, and motions that people have used to get ears: simply whistling and tossing up a handful of grass; tape recordings of wounded rabbits; brooms; children's toys; tin cans with gravel in them; cheerleader pom-poms; umbrellas; waving towels; party horns; gymnastics; and Jack Russell terriers lifted up off the ground.

The object used isn't as important as the technique and timing of the person wielding it. Most people, aware of the need for the horse's ears to be forward, start trying to get his attention before his feet are even set, especially when you are taking pictures in a public place. His curiosity is only

< **Remember that** the pose looks different from your helpers' perspective, so you'll need to direct them as they set up the horse. Explain in advance the approximate area in which you'd like the horse to pose, and why—because of the direction of the light, the background, etc.

⟩ What a difference two ears make! The ear person—the helper who grabs and maintains the horse's attention—is the unsung hero of the photo shoot. When the horse locks in on another person, horse, or object, you can get him to raise or lower his head and tilt it in any direction.

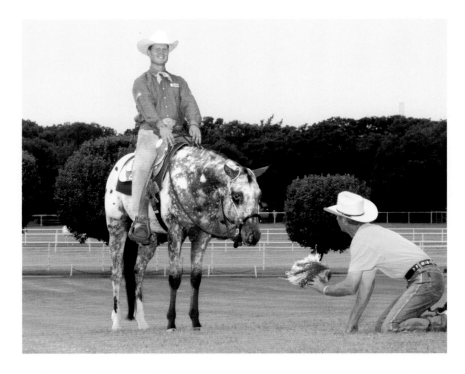

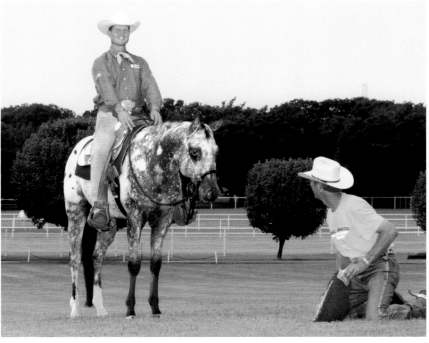

going to last for a few moments. You want him to be curious, but not determined to investigate closer. For instance, shaking a whole bucket of grain close by will often make the horse walk forward or stick his nose out.

If the horse's feet move, the ear person should immediately stop whatever he's doing to get the horse's attention. Continuing to do it too long takes the mystery and surprise out of the equation.

Professional photographer Don Shugart has come up with an ingenious prop for this purpose. He uses a mirrored tile from a home improvement store and has his helper hold the mirrored side toward the horse. Whether the horse is just intrigued by the shiny object or really admiring his reflection, as it appears in the photo, this technique seems to work exceptionally well.

The best way for you to learn how to communicate with the handler or ear person is to do the job yourself a few times.

Another method that has worked quite well is to have another horse nearby but not visible, hidden in the barn or behind a trailer. Once the subject's feet are in position, the designated ear person can lead the other horse out. Most horses will maintain interest longer in another horse than in a human clown.

I prefer a minimalist approach, such as subtle movement that piques their curiosity, or moving just out of the horse's range of vision. If you want him to raise his head, the best way to do so is to move the ear person or the companion horse further and further away, so he has to raise his head to see them.

Keep in mind that you must stay focused on the horse and ready to snap the picture when his ears go forward. You may not be aware of what the ear person is attempting, because your focus must be on the horse. When you need to give the ear person some direction, try to do so verbally without looking at him or her. You will not be popular with your helpers if you miss the chance to take the shot when the ears are in place because you're too busy yelling at them.

You need to remember to watch the entire horse, not just the ears, to know if the horse rests a foot or moves slightly or if his mane is out of place, because the ear person and handler might not notice.

Bystanders often tell me I should take photos of the ear person acting silly or desperate in their attempt to get the horse's attention. I always decline. For one thing, this person is helping me to do my job and I don't want to make fun of his efforts. Also, I don't want to take my attention away from the horse.

While you need to be courteous to everyone, remember your role as the director. If something should be moved or someone should be quiet, you need to be assertive. Remind them it is for the good of the picture.

What if you only have one helper? In chapter 7, we discussed determining where the horse will naturally want to look. This becomes even more important with only one helper because he or she acts both as handler and ear person.

∧ **If you only** have one helper, he or she will have to serve as handler and ear person. Pick your location so that the horse is facing the direction he naturally wants to look. It's usually much easier for the handler to move the front feet than the hind feet, so walk and stop the horse until he stops with his hind feet in the right position on his own.

∧ **With pasture shots,** it helps to have someone along who can attract attention, so the horses don't bend their necks around to watch the photographer. Here, a duck call and feed sack were also brought into play.

When I asked Don Shugart if he thought it was more important for a horse photographer to have people skills or photography skills, he emphasized people skills. Even if you don't intend to make this your profession, you'll have more fun and get better results if everyone is getting along and working together.

10

The Classic Poses

*Watch for these to occur naturally in posed or candid situations
and position yourself accordingly to capture them*

The Classic Profile

THE CLASSIC PROFILE IS THE UNIVERSAL STANDARD. IT IS THE
most flattering to the widest array of conformation types; it is the easiest
to take, as far as setting the horse up, and technically it requires less from
the camera.

You want the horse to stand balanced, with all four feet showing, and
the two feet closer to the camera farther apart than the other two. It's very
natural for the horse to stop and stand this way; it is similar to the way he
strides when he is walking. The last chapter went into detail about work-
ing with the horse and handlers to set up the classic profile.

Since it is so natural for a horse to stand this way, the trick is not
spotting such a pose, but evaluating it, deciding if it is photo-worthy, and
getting yourself in the right spot to capture it. And you need to do this
quickly, because he'll either move or go to sleep.

Because of the angle of the hock, when viewed in profile the back feet
will usually be farther apart than the front. Sometimes you may not see all
of both front feet; the one closer to you might obscure the other slightly.

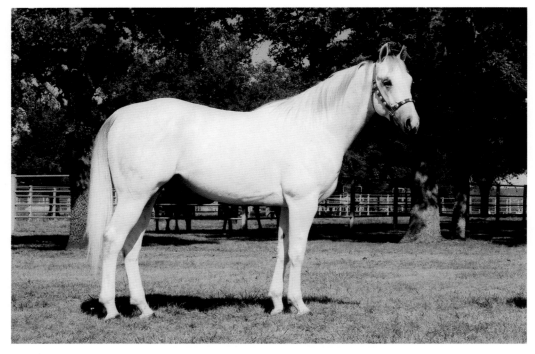

⋀ **It's very natural** for a horse to stand this way. Ideally, you want to see all four feet, with the front and back feet on the near side farther apart. The key word is balance.

Often this can be fixed by changing your angle slightly, moving a little farther behind the withers.

As stressed earlier, flat, direct lighting is the key if you're taking a conformation shot, so his profile should be perpendicular to the path of the sun. To know where he is in relation to the sun, observe where his shadow falls. It should fall directly behind him. Or just watch his profile and observe the shadow areas.

The photographer is in position at a point approximately even with the horse's withers or just a little behind, kneeling to lower the camera angle to a point approximately even with the center of the horse.

Rather than taking one shot or taking several from the exact same angle, move a few feet or inches in every direction and evaluate the horse through the viewfinder again. Even when you're convinced you've captured

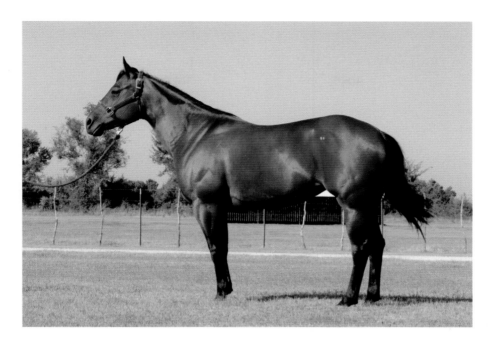

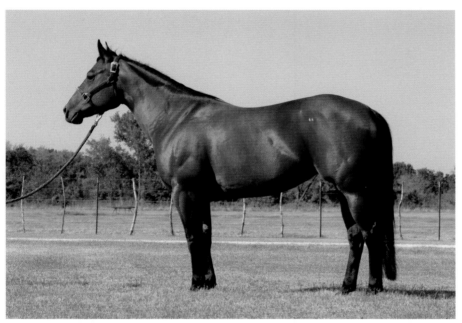

⋀ **Posing with** the front foot closer to the camera back and the hind foot closer to the camera farther forward never caught on as the "classic" because it makes a horse appear more short-coupled, as in top photo.

> **For three-quarter** views, ideally the horse should be standing with each foot squarely underneath him. From the photographer's perspective, there should appear to be a similar amount of space between each leg. Photo credit: Don Shugart

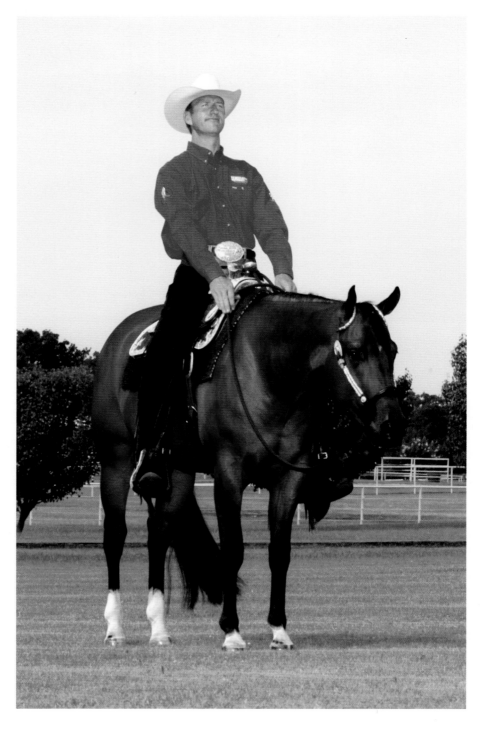

the most flattering pose from the most flattering angle, it helps to have others to which you, and others, can compare.

As discussed in chapter 5, "Technical Trade-offs," you can get the same exposure a variety of ways, by adjusting the shutter speed, aperture, or ISO. Two important factors influencing your choice of camera settings are the amount of available light and how fast a shutter speed you'll need to get a sharp image.

Typically, for posed portraits, we're shooting in bright light. We don't need a fast shutter speed since the horse is standing still. Therefore, use a low ISO and enjoy the benefits of better color saturation and being able to reproduce the resulting photo larger with less "grain" or "noise."

It has always seemed logical to me to set my 35mm SLR on shutter priority, set the shutter speed, and let the camera select the aperture. Camera manuals advise a minimum shutter speed of 1/60th of a second if you are not using a tripod, to avoid "camera shake"—movement of the camera while the aperture is open—which blurs the image. I prefer to set my shutter speed at 1/125th, because a professional grade telephoto lens is heavy and harder to hold steady. In certain conditions, I might select a faster shutter speed in order to use a larger aperture, which would further reduce the depth of field, if the horse were standing in front of a busy background that I wanted to be sure dropped out of focus, for instance.

You may have been told to use 400-speed film or to set your digital camera on 400 ISO because it is considered more versatile than 200 or 100 ISO. It is versatile, because it is light-sensitive enough to use in low-light situations or to allow you to use a fast shutter speed for action photos. But it isn't the best choice for portraiture.

The Classic Three-Quarter View

The classic three-quarter view requires a telephoto lens for technical reasons concerning the properties of lenses and magnification. The preferred focal length is in the 100mm range (using the universal language of 35mm photography). Also, you need a greater depth of field for this shot than for the profile. Adjust your camera so that you have an aperture of at least f8.

The horse should appear to be standing with each foot squarely underneath him, with a similar amount of space in between each leg. A common mistake is being positioned so far in front or behind the horse that you only see three legs, because the leg closest to you is covering the diagonal leg.

Focus on the vertical line created by the inside of the front leg.

Horses with riders often stop naturally with all four feet squarely underneath them. It is less common when horses are being led or are loose in the pasture. If you are attempting to pose the horse for a three-quarter shot (as opposed to randomly looking and waiting for opportunities for good shots of any type), you will probably need to set at least one foot to create this pose. Watch where the horse is in relation to the sun before you start setting feet; his chest should be illuminated as well as his side.

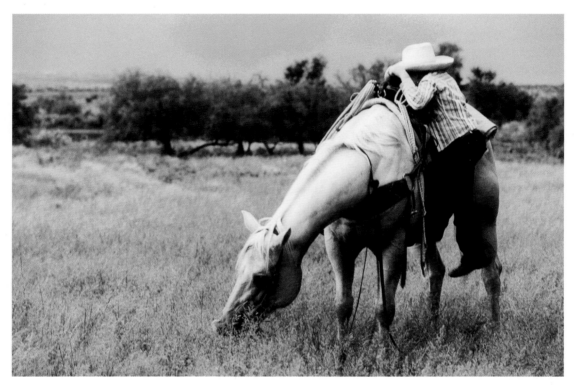

⋀ **Select camera angles** for candid photos with the classic poses in mind.

 Allow some visual space between the top of the leg closest to you and the diagonal leg.

For three-quarter shots, it's better if you walk the horse forward into position, rather than backing him. When you back him, it's typical for his hocks to turn in a bit more and his back feet to spread farther apart.

It's imperative that you lower your camera angle to get this shot. Otherwise the horse will appear imbalanced.

Classic Head Shots

The classic head shot is one in which the horse is showing a great deal of expression. The right ear person is a tremendous asset here.

You don't have to worry where his feet are placed, so this pose is easy to take without a halter. To control the background to some degree, you might want someone to lead the horse to a certain spot and then slip the halter off and hold him with the lead rope around his neck.

Head shots can be vertical or horizontal. If you don't have a telephoto lens, to avoid the extreme effects of distortion, stick with a horizontal shot

> **The background** detracts from this shot, and the way the horse is turned and the withers are cropped out makes the neck look abnormally short. This was taken from a relatively high angle, sitting on the fence and shooting across the pen.

⋀ **Moving the foal** away from the fence and lowering the camera angle changed the background to blue sky.

⋀ **To guide this filly** into the area under the covered arena where I could get this high contrast background and keep her there, the handler kept the lead rope around her neck, where it could be cropped out of the photo. This was taken for ads and packaging for Oster™ clippers. The filly was body-clipped for the photo session, although at this point only her head and neck were done.

of the head and neck and don't fill the frame with the horse's head. (To see examples, see the photographs comparing lens focal lengths in chapter 4, "Camera Considerations.")

A telephoto lens with at least 150mm focal length is preferred.

I like to find the plainest background possible. The doorway of a barn can be close to ideal if the lighting is right. If the horse is used to being in the barn, he's usually intrigued by what's outside it and anticipating what's about to happen.

A common mistake is filling too much of the frame with the head and not having enough of the neck in the photograph, which can make the

head look disproportionately large. You can always crop the photograph later, to make the composition more balanced.

As I watch the horse's expression, I look closely at his eyes, because capturing a highlight in his eye makes the photo much more appealing to me. In addition to creating dimension, it simply makes him look more alive. That's another reason I gravitate to the shot in the barn door: it creates strong directional light by eliminating overhead light. You get a similar effect at dawn and dusk, when the sun is low on the horizon. The reflected light in the horse's eye from this angle makes it appear larger and brighter, which horsemen subconsciously translate as signs of intelligence and vigor.

Head shots give you opportunities to experiment. Look to Arabian breed magazines for inspiration. After looking through a lot of proofs, both my own and other photographers', I concluded that there is no single, standard pose that you are trying to capture, no simple recipe for where you should stand or how much the horse should or should not turn his head. You just have to move around until it "looks right," an exercise that is both liberating and confounding.

11

Taking Pictures of Loose Horses

For photographers who want to be out standing in their field

PHOTOGRAPHS OF LOOSE HORSES, WITH NO HALTER OR BRIDLE to restrain them, are sometimes the most eloquent.

Besides choosing this type of photo because you like the look, you might also choose it if you're taking baby pictures, if you have no one around to help you, or if the horse you want to photograph isn't relaxed, comfortable, and responsive to a halter.

Sometimes our goal is purely aesthetic rather than an attempt to get a representative photo of a particular horse. Most of this book has focused on horse portraiture as a way to make you aware of lighting and background, how the camera sees things differently than the human eye, and what is flattering to a horse. All of these elements come into play when you're taking scenic pictures or "artistic" pictures of horses too. It is also a good time and place to experiment with sidelighting, backlighting, and silhouettes.

There are a variety of ways to go about photographing loose horses, depending on the situation and what you are trying to accomplish.

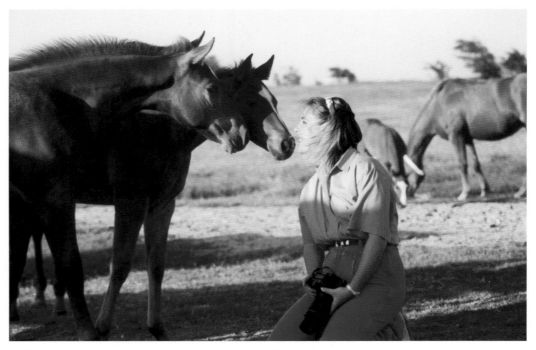

▲ **Photographers** are especially intriguing to young horses because we kneel down in the grass, which makes us less threatening and more of an oddity compared to other people. Until they get a little bored with you, it can be hard to get a picture, but be ready at all times. Photo credit: Carol Rose

If you have a choice of places to take these types of pictures, your criteria will be the broad strokes of what we talked about in chapter 7, "Scouting Locations." Take into account the direction of the sun and then evaluate where you'll have the best background. Look for objects like feeders that could get in the way, either in the foreground or background. Are other horses around? Where are they in relation to the pen or pasture you're considering? You'll have to use your horse sense to figure out what the horses are naturally going to want to do. And if you request to have horses, feeders, or vehicles moved from one area to another, to get a better shot, you'll need your people skills as well.

For compelling shots of an individual trotting or galloping, your greatest opportunity is usually when the horse first enters the pen, especially

The objective here was to take pictures of a friend's Paint filly for a potential buyer, and I was working alone. In her regular pen, which had obstacles like a couple of feeders, a shed, and a mudhole, I couldn't separate her from her buddy. They were so curious, they insisted on facing me so her head was always turned.

After moving her to an adjacent pen, she was more concerned about running back and forth to her buddy. I was able to capture her in the classic trotting pose and galloping with all four feet off the ground. It's beneficial to photograph both sides of Paint horses for potential buyers to evaluate, because they can look so different, depending on their markings. While these are not award-winning or flattering photographs, they served their purpose, and, combined with a copy of her pedigree, facilitated the filly's sale to an out-of-state buyer.

Notice how different her color appears in the evening light than when the sun was directly overhead

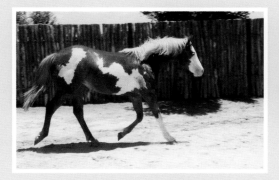

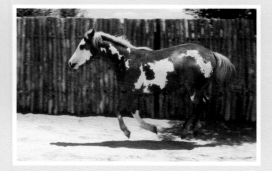

if he's been cooped up for awhile. This time is when the most natural prancing and dancing take place, when horses are moving about simply because they feel good. You can make them continue by chasing them around, but there's a point of diminishing returns.

It's helpful to have someone available to help direct the horse so that he stays within the range of the best background, with the better lighting. It can be hard to do on your own, because when you move the horse he's naturally going to move away from you, and you'll mostly be seeing his hindquarters.

Another person can also help by getting ears, or drawing the horse's attention away from the photographer. If you are by yourself, you can

△ **Look at the horses** and the landscape as abstract masses of color and shape and concentrate on composition. Here, the shadows in the foreground help frame the subjects, as do the fence and barn in the background.

⋏ **Look for ways** the foreground or background can frame your subject as this tree and the shadow it casts do here. If you want pictures of horses running, you'll benefit from at least one helper.

sometimes influence his ear and neck position by throwing something in the general direction you'd like him to look.

People are often tempted to feed the horses in order to photograph them in a certain place within a pen or pasture. Unless you specifically want pictures of horses with their heads down, eating, this tactic usually has little benefit. It's better to use your own movements to influence horse movements.

With baby foals, you can expect things to unfold like this: First they'll be a little unsure and skittish, and you might have trouble even keeping them in your viewfinder. They'll stick close to their mothers, and if they really aren't sure about you they'll stay behind her. However, if you leave

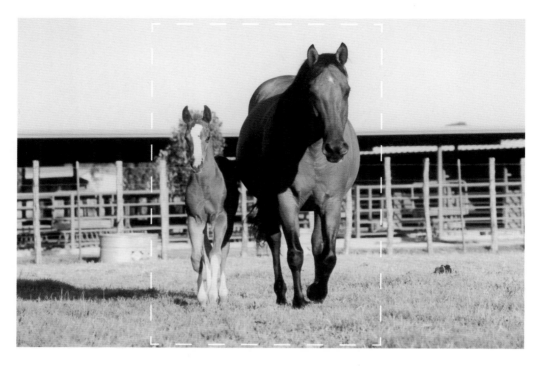

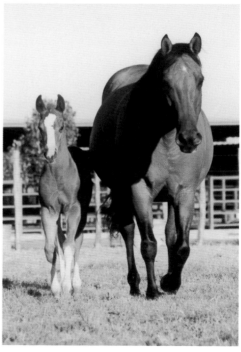

⋀ **When you first** walk into a pen or pasture, most horses will want to face you. Foals will want to stick close to their moms. Because you don't have much control over where the horses are or how long they stay there, you may have to take your best shot and crop more carefully later. Notice the way you can crop this shot to isolate the 'picture within the picture.'

⋀ **In this case,** I thought the shot with one ear cocked was a more interesting expression than with both straight ahead in the classic head shot pose at right, and I liked the composition better. On the other hand, shot from a slightly higher angle, it makes his neck look thicker. The comparison shot was a machine proof—an inexpensive print created via the machine's automated settings, which sacrificed the detail in the shadow area. Exposure, brightness, and contrast preferences are highly subjective.

them alone and sit quietly in one spot, they'll eventually grow curious and want to check you out. Photographers are especially intriguing because we kneel down in the grass, which makes us less threatening and more of an oddity compared to other people. You aren't likely to get a profile shot of foals during this phase, as they are going to want to face you, but a lot of times they'll stand really square and correct, with their little heads up and ears forward, and you can get good three-quarter front views.

As the foals get braver, they'll keep moving closer and closer, till all you see through the viewfinder are their noses. Until they become a little

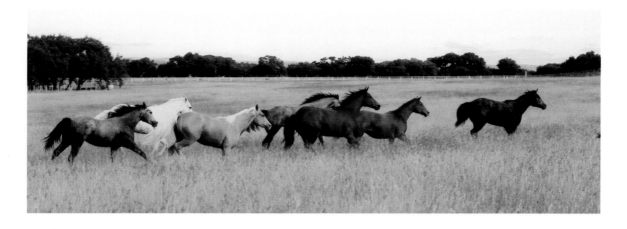

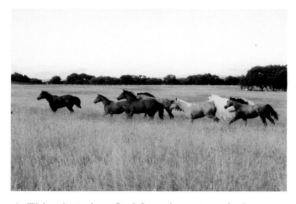

⌃ **This photo** benefited from the variety of colors of horses and from cropping and flipping the original image. People trained to read left to right tend to "read" pictures the same way.

bored with you, it can be hard to get a picture, but be ready at all times. Sometimes something more interesting or frightening or curious than you will get their attention, and they'll pose just like a champion halter horse.

It's really not much different when you walk into a group of older horses, except the older ones might skip past skittish and go straight to nosy and then quickly become bored.

While it's a challenge to create and capitalize on photo opportunities when horses are loose and milling about, I really enjoy it. It's an opportunity to put all your observational and analytical skills to use, to become really creative. Look at the horses and the landscape as masses of color and shape and concentrate on composition. Isolate the effects of lighting. This is an enjoyable way to develop the creative process of "thinking, seeing, doing," and become a better photographer.

12

Finding Flattering Angles

How camera angles affect the way
the horse looks in the photograph

BEGINNERS TEND TO STAND IN ONE PLACE AND SHOOT WITHOUT considering how the photo might change if they moved. Maybe they'll step a little to the left or right, but it doesn't occur to them to climb up on a chair or crawl down in a gutter.

Traditional conformation shots don't require crawling or climbing—but you still want to vary your camera angles within a modest range. With other shots—action, scenery, photojournalism, "art"—use your imagination and experiment with the whole range of angles. Just be aware of how angles affect the subject and to what degree they distort the subject's appearance.

Shooting up at a horse tends to make him appear bigger. Conversely, if you are shooting down on him, he'll look smaller. Shooting from an angle behind the withers will make him appear proportionately different than if you shoot from an angle in front of the withers.

Also, the more obvious effect is how the angle changes the horse's relationship to the background, which, in turn, affects the horse's appearance.

⋀ **These two photos** were taken 21 seconds apart, one from standing eye level, the other from a kneeling position, but all the camera settings are the same. The effect on the background is dramatic, but if you look closely there's also a difference in his body proportions. (He also raised his head slightly in the second one, which is why I like model horses as a teaching aid.)

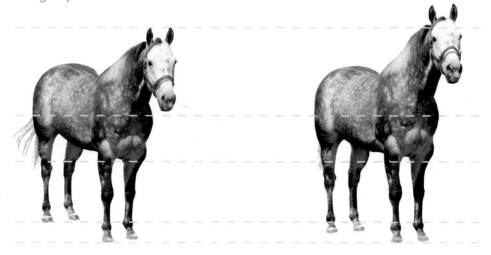

It can change the scale—how big or small the horse looks in relationship to the background. It can also change how the horse's image contrasts or blends in with the background.

Scale and contrast can draw attention to certain conformation traits or diminish them. That's why a good horse photographer has to understand which conformation traits are desirable and should be highlighted and how the dynamics of photographic imagery and composition can achieve that.

Evaluate the horse closely before you take the picture, especially if you are taking a portrait intended to show him at his best. Compare it to what is considered the ideal horse for its breed or sport. Using this comparison to the ideal will help you decide the angle from which to shoot.

For instance, if the horse is long-legged and gangly, you don't want to shoot him from a low angle, because that will just emphasize those

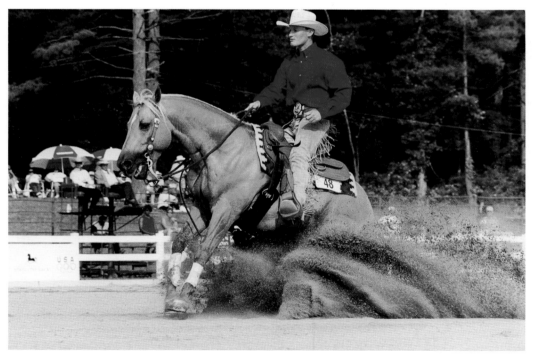

⋀ **An extremely low** angle exaggerated the flying dirt created by this stop. The angle also diminished the fence, umbrellas, and people in the background, which allowed the horse to really dominate the frame.

characteristics. And you would probably prefer a background where he blends in, rather than standing out in stark contrast.

When I talk about finding a flattering angle, I don't just mean a 90-degree angle versus a 45-degree angle; it might be 90 degrees versus 91 degrees. Small changes in camera angle can have a big impact on the photograph's background, what artist's refer to as "negative space," and therefore the overall composition of a photo.

You look at the background in broad strokes when you're scouting locations. When the horse is posed acceptably, you fine-tune its relationship to the background by making adjustments in your camera angle.

Because the horse dominates the center of a conformation shot, photographers don't always think in detail about composition. They

∧ **An extremely high** angle removed distracting background elements in this photo and made for an interesting diagonal composition. The angle completely changed the way the horses and women interrelate.

should obviously notice and work around disruptive elements, such as a telephone pole that appears to stick out of the horse's head. But as you

become more comfortable, start looking at the horse and the elements in the background as abstract shapes. Notice how the abstract visual mass of the horse interacts with the abstract forms in the background.

Watch for things like the way a horizon line or tree line bisects the horse. I prefer to have such a line fall above or below his underline, but not fall in such a way as to leave a triangle of contrast below his flank.

If you have a break in a solid mass in the background, I prefer that it appears the horse is coming out of the solid object rather than into it. In other words, if there are a lot of trees in the background and then a big open space, I prefer to have his head in the open space and his body in the trees.

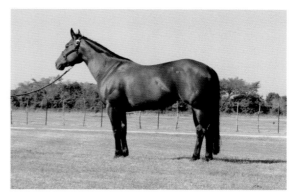

Another reason to take several shots from various angles is because people rarely agree in which picture the horse looks best. As I go through the proofs with clients and they select their favorite shot of each animal, I can show them the differences in the photos, but I can't always predict which they'll prefer. If asked, I might explain, "His body looks thicker here because the camera wasn't as low," or "because the trees in the background blend in and help create an optical illusion of more mass." Then I'll show them the next shot, where his body looks longer because it was shot from an angle closer to his tail than his head. But it's up to them to

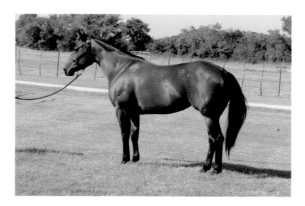

∧ **This is** the same pose from three slightly different angles. Notice how the angle affects the spatial correlation of the feet.

Analyze good pictures of good horses to develop your eye

■

Know what is considered ideal breed conformation

■

Ask the owner what they like, or don't like, about the horse

■

Experiment! Compare the results

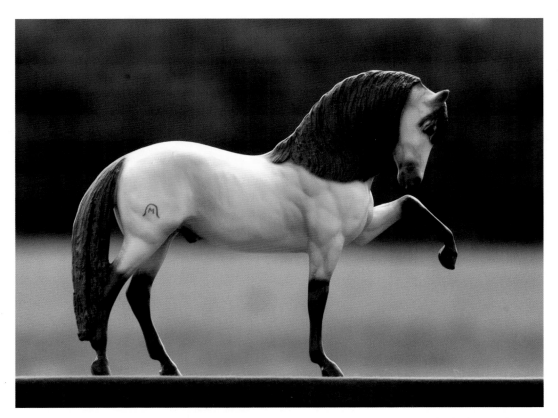

⋀ **Observe the way** the change in tonal value between the grass and evergreens in the background complements the difference in tonal values in the horse. The camera angle was specifically chosen so the darker green would define his underline. You wouldn't necessarily set out to find such a background and try to position the horse accordingly—it's hard enough finding a good background—but you'll notice these happy accidents and use them to your advantage once you start seeing the horse and background elements as abstract shapes.

⋀ **This is a full-frame** shot taken from underneath the announcer's stand at the National Finals Rodeo. Ordinarily I would not crop the heading horse or steer this way, but in this instance it enhances the feeling of being on top of the action, or rather, the action being on top of the viewer, and it focuses more attention on the heeler and his horse.

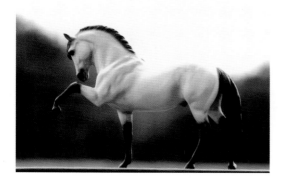
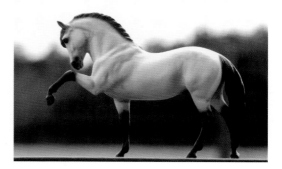

⋀ **Notice how** the horse's topline has disappeared into the sky in the left photo, making him appear swaybacked and shallow-hipped. In the right photo, the topline is outlined by the contrast created by the tree line, which stops just before the dark mane starts. Notice, too, how the difference in background affects the appearance of the head and neck.

⋀ **The identical pose** from two different angles. The illustration was taken to show how changing the camera angle changed the background, and how the horse blended in with the tree in the first background because it is of similar tonal value. Notice, too, that in the first he looks larger, because it was taken at a lower angle, and also because it is framed tighter (he is closer to the edges of the photo).

decide which is more flattering, or closer to what they're breeding for, or how the horse really looks.

This is also the reason to shoot more than one pose. Even if we could place each horse's feet in exact correlation to a blueprint of a great stance, it wouldn't be the most flattering pose for every horse. Photographers who can recognize positive and negative conformation traits have a real advantage once they learn how to use the dynamics of photography to play those traits up or down.

Again, I refer you back to the model horse exercise in chapter 6 as a way to isolate the effect camera angle has on the horse's appearance, and to isolate the changes in the background. In addition to relying on your own knowledge, ask the horse owner or handler what they like about the horse's conformation and what they would change if they could. People have different ideas of beauty and different priorities, and if you want the resulting photo to please the owner, accentuate what they consider positive. For instance, if they say they really like the horse's clean throat-latch and long neck, photograph the horse with his head out straight, to emphasize the throat-latch and neck.

13

Putting People in the Picture

Documenting relationships as well as individuals

ADDING PEOPLE TO A HORSE PICTURE IS A CHALLENGE BECAUSE you, the photographer, have to split your attention between the horse and the human. Not only do you want the picture to make both (or all) of the subjects to look good individually, you also want the overall composition to be pleasing.

One of the biggest challenges is lighting—the bright sunlight that is flattering to horses is too harsh for what is typically considered flattering to people. Another is getting the pose itself. The technique you use to engage a horse in order to get a good expression does not work on people, and vice versa.

While it is a challenge, the result can be greater than the sum of its parts, creating memorable photographs that have great significance for those who care about the people or horses involved.

Photographs of people are generally lumped into two categories, either posed or candid. My preferred approach to photographing horses and people together is a hybrid of the two. This hybrid strategy evolved

▲ **The little boy** had never led the big horse by himself, so his dad took some time to build the boy's confidence. Even though a family photo wasn't our objective, this candid shot is a keeper, in my opinion, because the composition illustrates the relationship between father and son and the father's role in the child's development as a horseman.

as I was taking pictures to go with articles in *The Quarter Horse Journal*. Typical posed photos of people with their horses, though efficient to take, would quickly start to look alike, plus they'd look like many of the advertising photos. And these folks weren't professional models, so posing didn't always come naturally. Candid photos told the story better, but it was hard to get a high percentage of useable photos relying strictly on snapshots in the short time spent on assignment.

This informal style of portraiture allows the photographer some control over the background and lighting and a chance to re-create the shot more than one time, which you wouldn't have with truly candid photography. The subjects were more comfortable because their attention was

⋀ **In this posed shot,** the dark background works well with the straw hat and light-colored horse, although it wouldn't have worked as well if the far door had just been open, without the silhouette of the tractor. Notice the difference in the lighting here, further under the eave of the barn, compared to the next picture, where they are stepping out into brighter light.

focused on something other than the intimidating fact that they were being photographed, and they looked more natural.

As with everything else we've discussed in the book, the choices you make will depend on many variables. Have you been asked to take a picture of a particular horse and person and they've set aside time for you, or are you a bystander at an event looking for photo opportunities? How's the available light? Is the person comfortable with the horse? Each situation brings a new opportunity for creative problem solving.

From a technical standpoint, a telephoto lens is more flattering to both of your subjects. If you have a "portrait" mode on your camera, it will automatically zoom the camera's lens out to its longest telephoto

setting. If you don't have a telephoto lens, remember the advice for avoiding distortion in your horse photographs and don't move in too close for a close-up. Another advantage of the longer lens is it allows your subject some space; they don't feel quite as much like they're under a microscope, being inspected.

A lower ISO rating is used for human portraiture, because of the greater color saturation, reduced contrast, and desire for a shallow depth of field, so that only the subject is in sharp focus and the background is blurred.

If you can selectively control the focus on your camera, then I suggest you focus on the horse, rather than the person, because the sharp focus

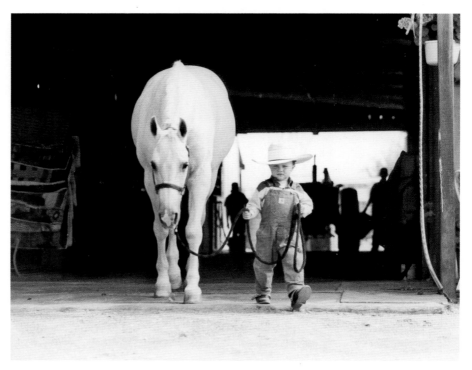

∧ **This is** an example of the hybrid between a posed and candid photo. It is more relaxed, less formal. I'd prefer more contrast between the hat and background, but it is the type of compromise you deal with in candid photography, and it could be improved upon with a custom print or some tweaking in Photoshop. This was taken from a much lower camera angle than the previous two pictures. I like that the horse's eye level matches the child's.

is more flattering to the horse, who isn't concerned about laugh lines. Where exactly on the horse you focus will depend on where the person is in relation to the horse. Keep in mind that you have more depth of field behind the plane of critical focus—the exact spot upon which you have focused—than in front of it. Depth of field extends approximately one-third the distance in front of the plane of critical focus and two-thirds behind the plane of critical focus.

The more competent you are at taking horse pictures, the faster you'll be able to assimilate the addition of other subjects. If you study human portraiture, you'll also be better prepared. There are standard people poses, just like standard horse poses. For instance, one "rule" is not to cut someone off at a joint—the knees, elbows, wrists, etc.

I like the subjects to seem connected in some way other than the lead rope. That might mean they're actually touching, or it might mean they are standing in such a way that directs attention from one to the other. Learn to look at them as abstract shapes rather than individuals and see how the shapes interrelate.

First we'll address the lighting challenge, then the three approaches from which to choose: either posed, candid, or the hybrid technique.

Lighting

The direct, bright sunlight that we generally prefer for a horse portrait is not what you'd choose if you were trying to get a flattering portrait of a person. People look better in diffused light, which is softer, less contrasting.

One strategy is to find a place where the horse can be fully illuminated by direct light and the person can be in bright shadow. This is a tricky balancing act. Sometimes the horse can even help provide the shadow, or perhaps you can place them in the entry to a barn, the horse in direct light, the person in shadow. It requires meticulous attention to the light on both subjects.

Balancing lighting for horse and human is one situation where a thin layer of clouds can be a photographer's best friend. We're hoping for what

⋀ **Though the lighting** and background in these two photos are similar, this pose isn't as flattering. Notice the way the woman's body is turned in the other shot, and the bend in her arm. Also, there is a highlight in the horse's eye in the other shot, which always makes the horse look more animated.

⋏ **Here the harsh** midday light was diffused by the shade of a tree. Fill-flash was used at
1/4-power, enough to compensate for the blueish tint of the shade, but not so much as to
look unnatural. Notice the patches of light on her shoulders and hat, where the sun shone
through the leaves. Finding just the right spot in the shade, where the light wasn't too
mottled, takes careful posing.

> **Open sunlight** is much more flattering to horses than to humans, although at least in this photo the shadow from her hat is cast evenly across her face.

photographers term "hazy bright" conditions, as opposed to dreary overcast. Such lighting isn't totally flat; you can still distinguish a difference between light and shadow, but the diffusion makes the difference less stark and dramatic than bright sunlight does.

When you don't happen to have hazy bright conditions, look for an area of open shade—a large area shaded by something like a mass of trees or building. Shade from trees can be patchy, with sunlight streaming through in inopportune spots, so make sure your subjects are evenly illuminated. Patchiness will be much more distracting in the print than when viewed in person.

Just as all light is not created equal, neither is all shade. Notice how the lighting on your subject changes—flattens out—the deeper into the shadow area you go. I prefer to pose my subjects just barely inside the shaded area, creating hazy bright conditions that still allow for some modeling of light and shadow.

A shaded subject in front of a brightly lit background can throw your light meter off, so be sure it is reading off your subject and not the entire scene. Also, when the photos are printed, the technicians might have to compensate for the machine's automated reading.

> **Adding People to the Picture**
>
> **Decide** whether to take posed, candid, or hybrid posed/candid shots
>
> ■
>
> **Reevaluate** the lighting for your human subject
>
> ■
>
> **Minimize** the background (both through selection and reduced depth of field)
>
> ■
>
> **Simple,** solid-color clothing generally preferred
>
> ■
>
> **For portraiture,** use a telephoto lens, low ISO, and shallow depth of field
>
> ■
>
> **Look** at both subjects as abstract shapes rather than individuals and see how the shapes interrelate

When I'm taking pictures of people in the shade, I prefer to set my camera like I would for a regular exposure and then add fill-flash at 1/4-power. There is a blueish cast to shade; the deeper in the shadows, the worse it appears. The boost of light from the flash helps correct the problem, but in a small enough dose that it doesn't look like flash photography.

If your priority is to get a good shot of the horse, with the person being secondary, you'll still prefer direct light. The optimum direct light is during what Jack Cardiff, a famous movie director, called "magic hour,"

the hour after sunup and the hour before sunset. But even Cardiff said in truth that magic hour lasts only a few minutes.

People naturally squint if they're posed in direct light, the reason they are usually wearing sunglasses and/or a hat if they're out riding on a sunny day. To keep them from squinting, have them look away from the light source, either by looking at the horse or looking in the same direction as the horse, instead of directly into the camera.

A hat will cast a harsh shadow across a person's face in direct sunlight. The shadows will likely appear more dramatic in your print than they do when you're taking the picture because our brains compensate for the difference between light and shadow. This is another reason to use a lower ISO rating, which results in less contrast between the light and shadow areas. The most effective solution is to add flash to fill in the shadow areas. However, most built-in flashes have a limited range of effectiveness. In that case, unless you are taking a head shot, you probably won't have enough flash power to compensate (unless you use a wide-angle lens and get right up on your subject, and then you'll have horrific distortion, like looking in a fun house mirror.)

Posed pictures

Posed pictures can be fast and efficient. You choose the lighting and background. You are the director and can impose the necessary changes to improve the composition, and you can enlist help to get the shot you want. If people know they are going to be photographed, they usually dress appropriately, and you may get to be involved in selecting their clothes, or picking colors that will complement the horse or background.

The downside is the people are usually uncomfortable being the focus of the camera's attention and it shows. It's difficult to get a natural expression. Or they'll be so concerned about the horse's pose that their natural expression is not photogenic.

One of the things you need to assess is just how comfortable the person is with the horse, with the camera, and with you. Many people own

horses that someone else cares for, and they know very little about them. If your human subject isn't completely comfortable with the horse, don't expect that person to move it for you or control it. You might even consider having a physical barrier between them, with the horse on one side of a fence or stall door and the person on the other.

Use your people skills. That's a broad description, I know, but figure out how to make your subjects feel at ease. Adapt to them; don't expect them to adapt to you. Sometimes, as the photographer, you forget what it's like on the other side of the camera. Just for a reminder, ask someone to take a picture of you and your horse. It can leave you feeling pretty vulnerable.

Explain to them what you'd like for them to do, and remind them to listen for your cues. It helps if you have another person helping who can concentrate on setting up the horse and getting ears, while you keep the attention of the person. Most people feel self-conscious about other people being around while they're being photographed, so keep that in mind when you're selecting a location.

Your subjects don't always have to look directly into the camera, especially if they aren't comfortable doing so. They can look at the horse or in the same direction that the horse is looking.

As for clothing choices, solid colors or small prints are best. Large patterns or a lot of decoration can be distracting. Trendy fashions or hairstyles will quickly date the photo, but that doesn't mean avoid them. Just be aware that the subject will probably feel like hiding the picture for several years, until the style comes back around again.

Candid pictures

Taking posed portraits has advantages, but often the results look *so* posed that people never really gravitate to them as an honest representation of the subject. While everyone appreciates a nice posed picture of the significant people in their lives, the good candid pictures are treasured even if they wouldn't win any photography awards.

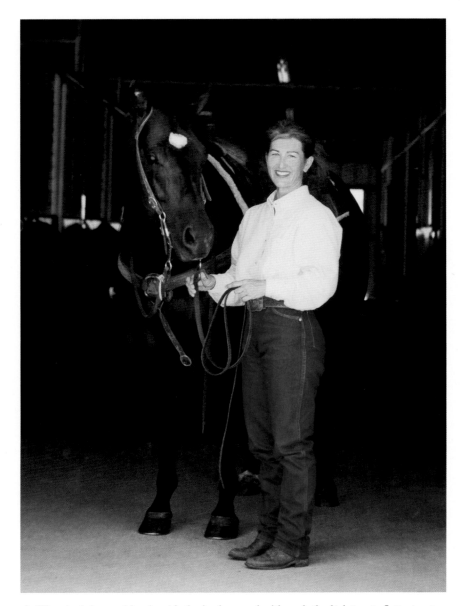

∧ **The dark horse** blends with the background, although the lighting is flattering to the handler. Look at the ground in this photograph and notice how much deeper the shadows become farther back in the barn. Pose your subjects just barely inside the shaded area, creating "hazy bright" conditions that still allow for some modeling of light and shadow.

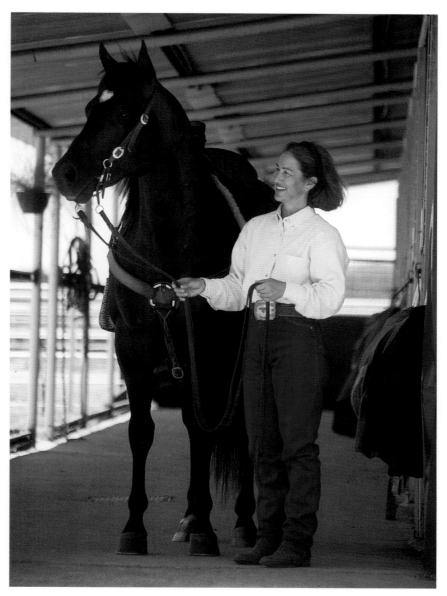

∧ **Posed pictures** allow you more control over lighting and background. The overhang on one side of the barn made a better location than the barn door because there was more available light, plus you could distinguish the dark horse from the background. If there is a lot of contrast between the tonal value of the horse's hair coat and the person's skin tone, you have an added challenge to balance the lighting, background, and exposure for both.

∧ **Technically** this is a posed portrait, although not a traditional one. The boy was dressed up to have his picture taken, but the grass stain on his knee reminds us he is a real child and not a mannequin. Although you can't tell much about the stallion's conformation, you can tell a great deal about his disposition.

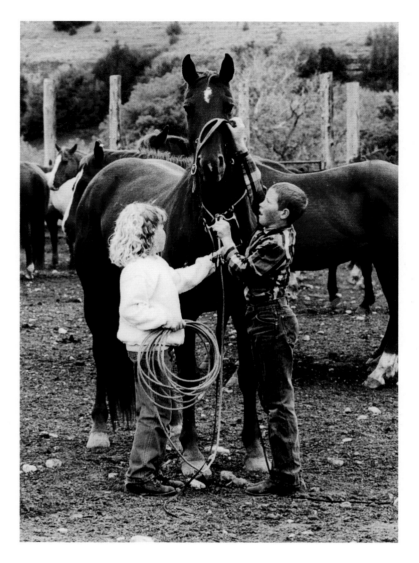

Candid pictures are easier with overcast skies, as you don't have to watch for harsh shadows and can shoot from a wider range of angles. The children weren't aware I was taking their picture, although the horse was—I was actually in another pen photographing something else when I saw the kids approaching the horses. A long lens is a great advantage for stealth shooting.

The dictionary defines "candid" as "free from bias, malice, or prejudice; honest and sincere." Candid photos are spontaneous and unposed. The television program *Candid Camera* used to say their subjects were "caught in the act of being themselves."

The subjects might be having a bad hair day and wearing work clothes, perhaps even dirty work clothes, for that matter, because they were focused on some activity other than having their image captured for

⋀ **The candid approach** is ideal for children. The pony is looking at the camera but the boy isn't aware of it. Is he aware of what he's about to step in? This image was cropped out of a larger one, so it isn't as sharp as it would have been if it filled the frame.

all eternity. Often, the subject's friends and family appreciate the resulting photos more than the subject himself does.

A snapshot in which subjects are aware of the camera, where they are momentarily stopped and were told to say "cheese," can be considered a candid photo. While the people are posing to the extent they might have their eyes open and mouth closed, you haven't carefully choreographed the lighting, background, and composition. Usually in these situations, your goal is just to get *something*, a way to record their presence on that day at that event. Use the available lighting and background to your advantage, but be prepared to compromise.

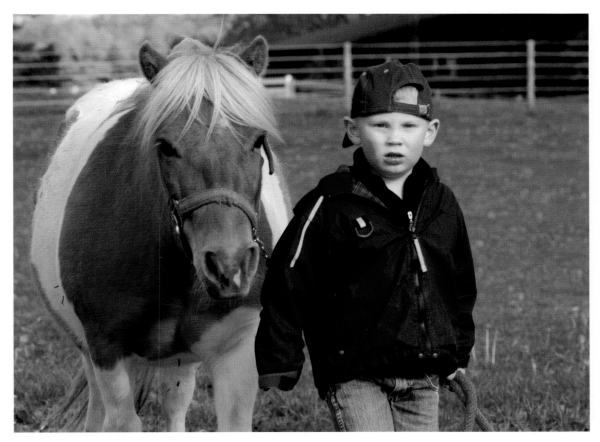

▲ **Once people become** aware of the camera, they often become self-conscious, although it doesn't seem to bother the pony.

︿ **This is a truly** candid photo, the type that would not win any photography awards because of the strong flash, but sentimental value overrides technical criticism. I use it as an example of why, in my opinion, you don't always have to see all of someone's face for it to be a portrait. The composition of the photograph can help create a visual link between the person and horse. That might mean they're actually touching, looking at each other, or looking in the same direction, or it might mean they are standing in such a way that directs attention from one to the other. Her arms around the bridleless horse create a visual link, and their expressions also show a link between them. Learn to look at them as abstract shapes rather than individuals and see how the shapes interrelate.

Consider adding flash to even out the lighting. Even though flash photography often looks flat or sometimes harsh, it's a good tool in this situation. Look in the manual and see what your flash range is, because you will usually be at least 30 feet from your subject if you have the whole horse in the frame.

I prefer candid pictures that are photojournalistic, which are truly unposed and spontaneous. For this style of photography, dial back your presence until people forget you're there. A long telephoto lens allows you to physically stay out of their space. It also reduces depth of field, blurring the background or foreground and reducing its negative impact.

I love these photojournalism opportunities. It's my version of hunting. You need stealth and quick reflexes. It can be frustrating: so many shots that would be fabulous except for the horse looking the wrong way or the golf cart in the foreground. But no one else knows about the ones that got away. And the ones you capture can re-create a place, person, event, or atmosphere better than a series of posed photos.

Photographs of people are generally lumped into two categories, either posed or candid. My preferred approach to photographing horses and people together is a hybrid of the two.

If you are taking these pictures in a public place, your photo opportunity may only last a few seconds before other people interrupt your line of vision or divert your subject's attention. Because the subjects aren't posing, it takes careful timing to catch them without their mouths open, eyes closed, or worse.

One strategy is to pick a place where the background and lighting is appealing, and then wait for a subject to enter that space. The diffuse light created by overcast skies can be to your advantage when taking candid pictures of people and horses, since it eliminates harsh shadows and lets you shoot from a greater variety of angles.

The hybrid: combining posed and candid photography

Hybrids have the advantages of both posed and candid pictures and minimize their disadvantages. It is an especially effective way to photograph children and deprogram those who have been trained to "smile for the camera."

You select a potential background and the lighting you want, then give your subjects an activity and broad direction. This is usually a relief for the subject, compared to feeling like a mannequin and contorted into a fixed pose. They can focus their attention on doing something or on the horse, which circumvents artificial-looking poses. Unless you're photographing a professional model, most people feel awkward in front of the camera and it shows.

Not everyone likes these types of pictures. Some people will complain, "Well, he's not looking into the camera," or "You can't see all his face," and that is often the case. The person's hair might not be perfect, or the horse might not have his ears up. It's definitely more casual.

As with posed photos, you need to establish a rapport with your subject. You'll want to assess the person's comfort level with the horse and with what you are asking him to do. Take a little time to get acquainted with the person before you take your camera out. Don't ask people to do anything outside their safety zone. But if you can coax them out of their *comfort* zone—broaden their comfort zone, if you will—you can all have a lot of fun and get some memorable shots.

14

Capturing Action

Photographing the horse in action requires
faster reflexes and better equipment

THE CLICHÉ IS RIGHT—IT'S HARD TO SHOOT A MOVING TARGET.
Action pictures are a greater challenge for the photographer, as well as the
photographer's equipment.

Good action photography requires all the skills of still photography
at an accelerated pace. You're still doing the same thing—simultaneously
seeing, thinking, doing—but the process has to speed up right along with
the horse's motion.

You have to anticipate the fraction of a second when the horse is at
a certain point in his stride. Not only must your brain get the message
to your shutter finger, your automated camera needs time to react too.
How much time will depend on your particular camera. Experience can
sharpen your reflexes, but your camera's limitations are something you
have to learn to work around.

Knowing when to shoot is one thing; having the camera in focus at
that moment is another challenge. And getting a good exposure is yet
another, because the faster shutter speed required to stop action and the
longer telephoto lens needed to get close to the action mean trade-offs

somewhere else. This is why you're generally advised to use a higher ISO rating when shooting action.

Most current advice on action photography assumes the reader will be using a 35mm SLR camera with a shutter-priority mode and telephoto lens, because that system is what consistently yields the best results.

You can get good results with a point-and-shoot, fixed lens, or disposable camera if you can get close enough to the subject, you have enough available light, and the action isn't too fast. How close is close enough? How much light is enough? How fast is too fast? Like so much related to photography and horses: It depends. Capitalizing on sunny days, profile shots at a slower pace (such as rail classes, dressage, trail, or the sliding stop), or wider-angle shots (for example, team roping) will increase your odds.

Much depends on the camera you use.

Because of the diversity of what's on the market and the rapid changes in technology, giving specific information about getting the most from a particular camera is impossible. Different models have different top shutter speeds, for one thing. And sometimes the photographer has little or no latitude in adjusting camera settings. Supplement the advice in this chapter by rereading your owner's manual—specifically, any reference to action photography. Online forums or camera manufacturers' Web sites can be helpful, or you can also seek one-on-one help from salespeople at a professional photo lab or camera store.

While digital technology is advancing rapidly, the shutter lag inherent in many consumer digital point-and-shoot cameras at present makes them impractical for action photography. Shutter lag means a slight delay

How to improve your odds

Shoot outdoors on clear or hazy-bright days

■

Prefocus

■

Choose an angle where the horse is traveling parallel to the film plane, as opposed to traveling toward you or away from you

■

Use a high ISO, 400 or greater

> **Competitive action** is fun to shoot when the horses are top-notch. This angle lets the viewer appreciate how high the horse is jumping.

⋀ **In action** photography, it's easier to take the profile than the three-quarter front because it's easier to focus (he remains in the same focal plane) and it requires less depth of field.

between the moment you press the shutter release and when the camera records the image. When you are trying to capture a horse at the apex of his stride, even the slightest delay can cause you to miss the shot. You can try to compensate for the delay by anticipating the action. However, it seemed the length of delay in my first digital camera was inconsistent from one situation to another; there was less delay in bright light than low light.

On most models, there is also a delay after you take the shot, while the camera stores the information to memory. Some models have a "burst-mode," which allows you to take several shots in a row, but at low resolution.

A lot of people like to take a machine-gunner's approach to action photography if they have a camera capable of taking a sequence of shots in rapid succession. I have learned to appreciate more of a sniper's approach. Even with a professional camera that can fire off six frames per second, you can miss a shot. When you are aiming for something as precise as the racehorse's nose at the finish line or a hunter at the height of a jump, you usually end up with one shot just a little too early and one just a little too late. And most cameras won't shoot six frames per second.

We've been told for years, and still fully anticipate, that digital video (DV) will revolutionize action photography. DV records 30 frames per second, about five times more than most 35mm SLR motor drives. You can follow the action for hours, as opposed to short bursts lasting only a few seconds. At this time, resolution is still insufficient to make a really good print from a DV frame. But it's inevitable, and once it's feasible, going back to the old-fashioned way might seem pointless.

I'm just glad pulling a frame off DV wasn't an option before I began to photograph horses in motion and equestrian sports. Sifting through my own files, I found stacks and stacks of action pictures that were poorly timed or technically flawed. But in pursuit of the good ones, I learned to concentrate and analyze horses' movements in a way I never had before. It's made me a better rider and more observant spectator at horse events.

The jog or extended trot makes the ideal "schooling shot" to start honing your reflexes and learning the limitations of your camera. The classic photo of the horse at a trot is the moving equivalent of the classic profile. The pose is even similar, with the hind foot closer to the camera further back. The horse is moving parallel to the focal plane, so you don't need much depth of field, and the horse is moving relatively slowly, so you don't need a much faster shutter speed—1/250th should suffice. The cadence makes it easy to get your timing.

Timing an action shot is one thing; having it in focus is another.

It is easier to focus on a horse that is moving in a horizontal plane in front of you than one that is coming toward you or going away from you.

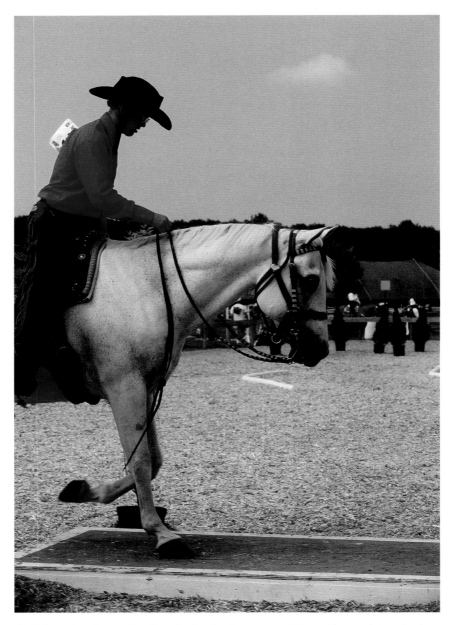

⋀ **Take advantage** of prefocusing to shoot any competition with a predetermined course, like trail, jumping, and barrel racing. In this case, looking through the viewfinder you would center the frame on the edge of the bridge, then press the shutter release halfway, so that it will focus and set the auto-exposure, then reframe your shot to anticipate the next rider. This is especially helpful if you have a digital camera with a shutter lag problem.

When the horse is crossing focal planes, as when he is coming toward you, you have to continually refocus. The faster he's traveling, the faster you have to focus. Since most people are relying on autofocus, it would be accurate to say, "the faster *the camera* has to focus." Faster autofocus capability is one of the critical differences between consumer and top professional lenses.

In other words, it is easier to maintain focus on the horse as he passes in front of you in profile than if he were galloping toward you at a three-quarter angle.

One alternative is to prefocus—to focus on a certain spot in advance of the horse reaching it and then take the picture when the horse is at that spot. This is especially useful for jumping, barrel racing, and race finishes—anytime the horse's course is predetermined. To prefocus an autofocus camera, choose a stationary object that the horse will be passing close to and lock the focus on the object. Lock the focus by centering the viewfinder on the object and pressing the shutter button halfway down. While holding the shutter button halfway down, re-aim the camera to frame the shot as you anticipate the horse moving into view. Hold that focus until the horse moves into the frame and then press the shutter button the rest of the way.

It's also easier to focus on action that is further away than when it is really close up—another advantage to the telephoto lens.

Action photography requires a faster shutter speed than still photography in order to "freeze" the action in the photograph. The shutter speed is the length of time the lens aperture is open and gathering light, the key ingredient that records the image. (Remember, photography literally means "writing with light.") Any movement during the time the shutter is open is recorded as a blur. Blurring can be a great creative effect, but it is frustrating if it wasn't your intent.

The faster the horse is moving, the faster the shutter speed needed to freeze the action. Most action photographers suggest a minimum shutter speed of 1/500th of a second. I often shoot at slower speeds, either because I'm in low-light situations or because I don't want to sacrifice

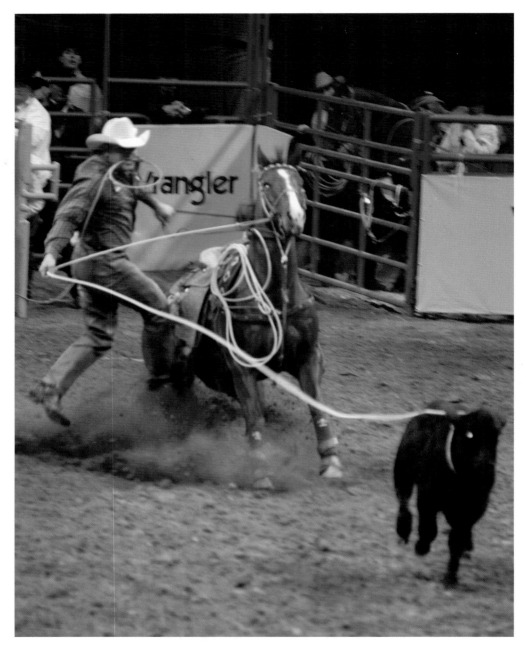

⋀ **The camera** was set manually for shutter speed of 1/125th @ ƒ2.8 to get the benefit of the ambient light in addition to the external flash unit, which wasn't much help at this distance, from one end of the arena to the other. Had this been a profile shot, the low depth of field would not have been such a factor.

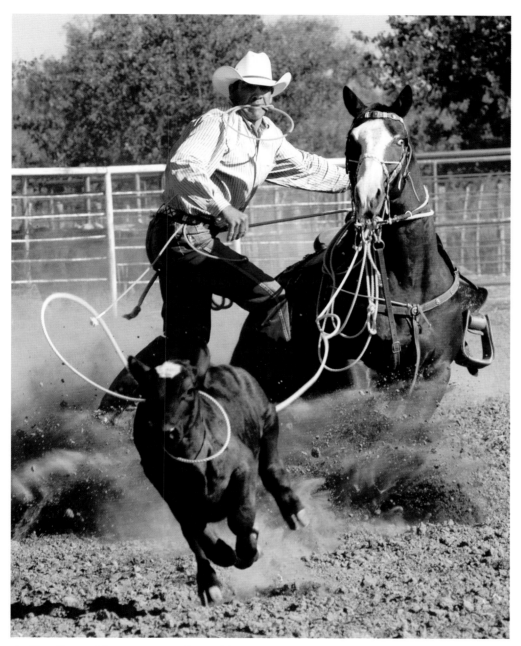

⋏ **Shooting outdoors** on sunny days yields much better results than in an indoor setting.

grain/resolution or depth of field, but then I also get a lot of pictures that aren't as sharp as I'd like.

Remember that a faster shutter speed means a trade-off somewhere else, either in aperture, ISO, or underexposure. As mentioned in chapter 5 on technical considerations, the amount of exposure needed to get a good print is determined by the amount of available light. Therefore, the more available light that your camera has to work with, the easier it is to get good action shots.

Adding flash to increase the amount of available light always seems like an easy fix, but most consumer flashes are not powerful enough to make an appreciable difference unless you are really close to the action. Read your manual to learn more about your flash's capability, the distance it will cover, and the most effective mode to get the most out of it. Also, if you are shooting a competition and plan to use a powerful flash, you should secure permission first. Camera manufacturers may say that a flash's duration is so short that it won't distract a horse or rider, but a lot of riders will tell you differently. It doesn't matter whether it is truly potentially distracting or just that some people have that perception. The photographer's presence should never compromise a contestant's belief that he or she had a fair opportunity to compete without interference.

The trade-off between shutter speeds, apertures, and ISO is the reason sports photographers don't automatically set their shutter speed to the fastest available. As you become more experienced and see the results of different shutter speeds, apertures, lens focal lengths, and ISOs, you'll gain more creative control and more consistent results.

"Panning" is another technique for shooting action. Instead of freezing the action with a fast shutter speed, you use a slower speed and "pan," or move horizontally, across the scene at the same speed as your subject. The camera movement creates a blurred background, but the horse will be sharp if your timing was just right. Often the horse's feet will be blurred while the body is sharp, because the feet are churning so much faster. Generally, a shutter speed of 1/30th of a second is used to pan.

As you're developing your timing and mastering your camera settings, you also need to remain conscious of such details as lighting, background, and finding a flattering angle. A situation where you set up the action is much easier than when you are photographing competition. However, the most dramatic shots logically derive from competition rather than the practice pen.

Of course, you can have the ideal setup—lighting, background, lens, etc.—and capture the apex of the action, but whether or not the horse's connections think it's a good picture depends a great deal on the horse and rider. While you can watch for and try to avoid shots of horses with their mouths gaping open or riders that are out of position, you can only do so much.

If you want to photograph an event and your camera isn't suited to capturing action or you can't get the necessary credentials, concentrate instead on other ways to illustrate the competition. Professionals with life-savings-worth of equipment can provide a great action photo, but while they focus on the competition, you can capture the drama at the back gate, the good-luck kiss, or appreciative pat to the horse's neck when no one else is looking.

Standard shots proven to be classics

THE TROT

The standard shot of a horse at a trot is the classic profile in action. Like the classic profile, it is taken with the subject parallel to the camera. You can control the action (assuming you have a rider involved). You can control the background, slope, and position of the light source.

The trot is a two-beat gait, so it's easy to get in rhythm. You want to capture the horse's feet at the point of greatest extension. Your goal is take the shot when the front foot closest to you and the rear foot on the opposite side reach forward. The cadence of a horse's trot makes this an easy picture to anticipate.

Ideally the horse should be directly in front of you when you click the shutter. While you're learning, start counting "1-2-1-2-1-2" in your head in rhythm with the trot before the horse is directly in front of you.

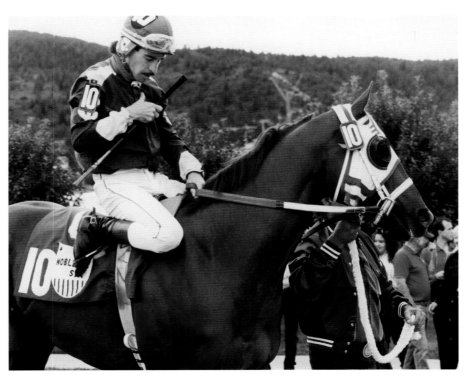

⌃ **If your camera** is not suitable for action photos, look for other ways to document events or competition. The jockey said later that his father was as proud of this picture as the one taken a few minutes later when he crossed the finish line to win a million-dollar race.

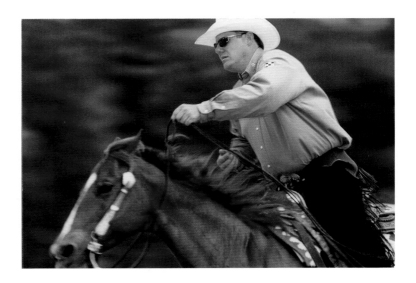

❯ **You can imply action** in close-ups and exaggerate the effect with panning, which means moving the camera along with the action while using a relatively slow shutter speed.

⋏ **This is an example** of why flash photography is tricky for shooting action indoors. The flash level overexposed the rider barely in the picture in the lower left corner—notice the shadow. It's ideal for the Paint horse; its effect can hardly be seen on the next two horses, while the ones beyond that are lit only by the overhead lights. The combination was perfect for this image, but you won't always be so lucky.

> **An example of the** creative potential of panning, where the camera was focused upon and moving in sync with the horse's head, with a shutter speed of 1/50th of a second @ *f*18, with the ISO set at 200 and a lens focal length of 112mm. This is more of an artistic approach, as opposed to documentary.

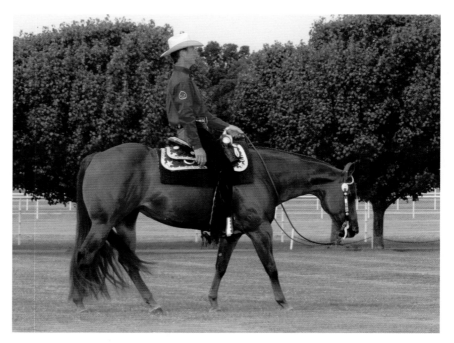

⋀ **The trot** is a good schooling shot for action because it's relatively slow. Photo credit: Don Shugart

⋀ **Time the shot** when the front leg closest to you is extended. Because the trot is a two-beat gait, it is easy to get in rhythm.

⋀ **At a slow lope** you can time your shot for when the lead leg is fully extended.

⋀ **This shot isolates** the point in the stride when all four feet are off the ground. Stay aware of the lighting, flattering angles, and background, in addition to capturing the action.

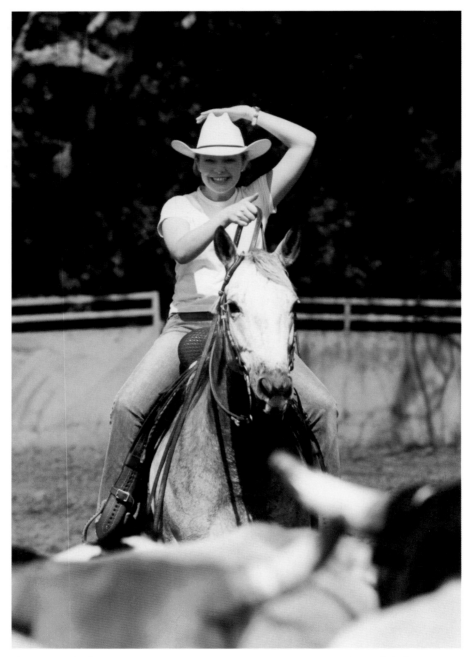

⋀ **The goal of this part** of the photo session was to get an action photo of the horse cutting cattle, her specialty, but I liked the rider's expression as she rode into the herd. It's great to be able to spot the classic poses, but don't limit yourself to them.

⋀ **While a low** camera angle flatters a horse, often a higher angle like this will allow you a better background, plus it can be taken from the stands, rather than inside the arena or through the fence.

This technique for shooting the trot is the same whether the horse is being ridden under Western or English tack, or, for that matter, being ridden at all. It's a great way to show conformation.

THREE-BEAT GAITS: THE CANTER/LOPE/GALLOP

Photographing the gallop will help you appreciate the biomechanics of the equine. There really isn't a classic gallop shot, but the horse does tend to look more graceful with weight on the hindquarters or when all four feet are off the ground.

Action photography revolutionized the world's understanding of the way horses move at the gallop. Prior to 1872, people believed that when a horse galloped his front legs were extended in front, and his hind legs

extended behind, splayed out like a rocking horse. You'll see it in depictions of the running horse from the cave man's drawings all the way to Degas' early race scenes. To settle a bet, California Governor Leland Stanford hired Eadweard Muybridge to use the then revolutionary process of action photography to document the various gaits of horses. His photographic proof changed the prevailing view of how horses moved at a gallop (and apparently caused Degas to revise some works in progress). Your own photos may change some of your perceptions.

BARREL RACING

The classic shot is taken as the horse turns the second barrel. The photographer should be positioned at approximately the scoreline, next to the fence. This shot is generally taken at the second barrel because the horses are all in a relatively similar position as they make the turn. At the first barrel, horses come into the turn at more varying positions. Although the position of the horse and rider is similar at the third barrel,

⋏ **A standard lens** will work fine for team roping shots, since you are taking in a wider scene than in most competitive action.

it would be difficult for the photographer to be positioned in the correct spot to capture the turn, since the third barrel is set in the center of the arena.

TEAM PENNING

The classic shot in team penning is taken as the cattle enter the pen and the riders raise their arms to signal the end of the run. Position yourself so that you will see the riders entering the pen.

TEAM ROPING

From a technical standpoint, team roping pictures are relatively easy to take, if you are in the right spot and it is an error-free run. You don't need a long telephoto lens, so you have an extra f-stop or two of light to work with, nor do you need much depth of field. Position yourself on the right-hand side of the arena (as you face the roping chutes), about two-thirds of the way down the arena. The classic photo is taken when the header has caught and is turning the steer for the heeler. Ropers will like the shots that show their horses in the correct position, like in the photo on the previous page. To time this shot, watch the steer's head and shoot as it changes directions. This shot is easier to take than the heeling shot because it is easier to predict where it will take place and because the action is usually closer to the center of the arena. The classic heeling shot is taken when the heeler has already thrown his loop and is pulling up the slack in the rope, before he dallies the rope around the saddle horn. To time this shot, the natural follow-up to the heading shot, watch the heeler's hand as he releases the rope and then pulls the slack before dallying, anticipating the point when his hand is highest in the air.

CALF ROPING

The classic shot is taken as the roper is dismounting after pitching the slack in his rope into the air, as the horse is sliding to a stop. (Remember, calf ropers dismount on the right.) A profile shot is easier to focus, although the space between the horse and calf, when viewed from the

▲ **Your highest percentage** of good bucking horse shots will come early in the ride, for two reasons: a lot of horses lose steam the further they buck, and a lot of cowboys are ejected before they get halfway down the arena.

side, means the horse won't dominate the frame unless you crop the calf out. A three-quarter front or head-on view creates a better composition. A head-on shot can be especially dramatic, if the calf doesn't block the view of the horse.

REINING

The sliding stop is the hallmark photo opportunity in reining. The advantage of shooting reining is that there is a predetermined pattern containing more than one sliding stop. Find out what the pattern is in advance to position yourself in the best spot with regard to the light. It's

easier to take the profile than the three-quarter front because it's easier to focus (he remains in the same focal plane) and it requires less depth of field. As the horse slides with his back legs, he continues to run with his front legs. You'd like to show a division between his front legs when his hind legs are deep in the stop. The more dirt flying, the better!

BUCKING HORSES

The classic shot is when the horse has all four feet off the ground and the rider's feet are at the foremost point of the spurring motion, with horse and rider at their fullest extension. To get a good profile shot, which is easier to take and the most popular angle, position yourself about a third of the way down the arena from the bucking chutes. Your highest percentage of good shots will come early in the ride, for two reasons: a lot of horses lose steam the further they buck and a lot of cowboys are ejected before they get halfway down the arena. Hint: while

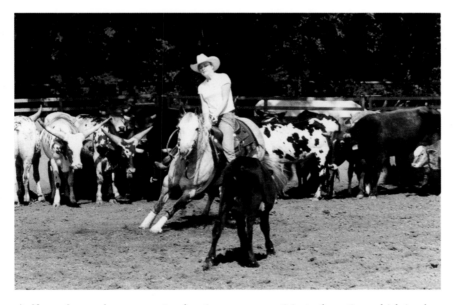

∧ **If you know** the sport you're shooting, you can anticipate the action, which is why so many photographers specialize in one aspect of the horse industry.

you're learning, concentrate on where the horse's front feet are rather than trying to take in the whole scene, and time your shot to coincide with when the front feet are off the ground. Great bucking horses seem to hang in midair. The better the horse, the easier it is to get a good picture.

CUTTING

The classic shot captures the horse when he is locked in on the cow with his head low and his body at the point of changing directions. To time your shot, watch the cow's head, and be prepared to shoot the instant he changes directions.

DRESSAGE

The standard dressage shots are those that show a horse's extended trot and canter from a side or three-quarter view. The trot, in particular, should catch the horse with foreleg closer to you fully extended. Two movements that are included at the highest dressage levels are also classics: the passage (pronounced in the French fashion as "pah-SAHZ" and meaning a trot with great leg elevation and suspension) and the piaffe (a highly collected trot in place, pronounced "pee-AHF"). These, too, look best with the foreleg closest to you extended forward.

Dressage tests begin and end with a halt, during which the rider salutes the judge. This classic pose is much easier to shoot than the action and less of a strain on your camera's capability.

JUMPING

The classic over-fences photo shows the horse at the highest point of the jumping arc, with the forelegs folded in as close to 90-degree square knee-and-ankle angles as possible.

While the timing has to be exact, being able to prefocus on the jump rail and knowing exactly where the action will take place allows you to anticipate the shot.

The best angle is a three-quarter shot, because the jump standard (the post that holds the rails in the cups) will be in the way if you shoot the profile, unless it is an exceptionally tall fence. Also, shooting up at the horse from a lower angle makes for a more dramatic shot; it creates the optical illusion that the horse is jumping higher than if you shoot from standing eye-level.

Oxers, which are wide multielement jumps, require a horse to stay in the air longer than verticals do, so you have a marginally longer time to catch the moment.

Not that a photographer has much control over how a horse or a rider will take a fence, but if you're not familiar with show hunters and show jumping, you should have some idea of what's correct before presenting participants with a record of major errors and faults. The rider, trainer, and owner of a hunter won't care for a photo that shows the horse with uneven knees at the top of a fence or, worse, with one leg way in front of the other. Both are serious faults. Nor will a hunter-seat equitation rider be happy to see herself either perched way up on her horse's neck or leaning back after being "left behind."

HORSE TRIALS AND THREE-DAY EVENTING

In addition to the dressage and traditional jumping shots already covered, the cross-country phase affords many picture-taking opportunities as horses and riders gallop for up to four miles over such unyielding obstacles as logs, stone walls, and barrels on their sides, as well as across ditches and through water hazards. Walk the course in advance to decide which obstacles you find the most photogenic, then start your picture-taking at the last such obstacle and work your way back (horses begin the course at approximately five-minute intervals); that way the horses will always be heading toward you.

Standing too close to the obstacle will distract the horses and riders. The fence judge or another competition official will ask you to move. Even better, ask first.

15

Taking Your Camera Along for the Ride

Advice for branching out from the barn,
taking pictures in wide open spaces,
or on group rides

IF YOU LIKE TO RIDE *AND* YOU LIKE TO TAKE PICTURES, YOU MIGHT think combining the two would rival nirvana. My experience is that rather than doubling the fun, enjoying either activity requires a significant compromise of the other. Therefore, before you saddle up, I suggest you decide which takes precedence: Are you going on a trail ride or a photo shoot?

Most people are just taking their camera along for the ride, a ride they'd be going on anyway. They just want some pictures as mementos of the trip. If that's the case, you might consider taking a one-time-use or disposable camera. You don't risk damaging your more expensive camera, and the lens, with its wide angle of view, will take in lots of scenery. Just remember its limitations. The prints won't be as sharp, and you don't want to take three-quarter views or head shots at close range because of distortion.

If you are intent on getting good photos, you'll have less frustration if you plan the ride yourself rather than joining an organized trail ride hosted by someone else.

▲ Planning a ride
with other photographers
is ideal, because they
appreciate the value
of light and tolerate
frequent photo stops.

Organized trail rides are staged to accommodate riders' schedules, not photographers', so they usually start just as the beautiful morning light is evolving into harsher midday light and end before the afternoon light becomes golden.

Shooting from on top of your horse makes it harder to get precisely where you want to be and then to stay there. If you're taking pictures of other horses, your camera angle is higher than you'd usually like. If you've got to move to catch the action, by the time you've cued your horse and gotten where you want to be, your subject has probably moved again. You need a faster shutter speed to compensate in case the horse moves, which he'll probably want to do, because it goes against equine nature just to stand and let the rest of the herd ride off.

If you dismount and hold your horse, he might tug on your arm just as you're taking your shot. If you trust he's trained to ground-tie, asking

him to stand while other horses pass will be an excellent test. But just remember that if he fails, you'll either have a long walk or the humiliation of someone else retrieving him for you. By the time you're trying to remount, he'll be anxious to catch up with the group, with or without you. And it isn't enough to catch up; unless you pass the group so you can get

⋀ **Most formally organized** rides begin about the time the morning light turns harsh and end before the afternoon light turns golden.

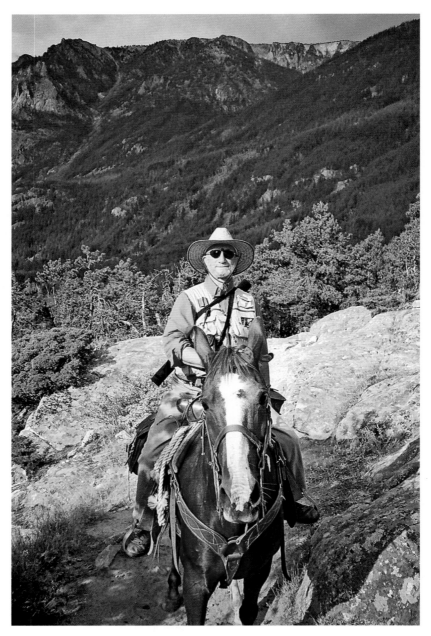

⋀ **Unless you** skipped chapters 1 and 4, you probably know why the horse's head looks so much larger than the rider's. However, while riding up a narrow mountain trail is not the best time to suggest a rider turn his horse sideways so you can get an undistorted view of his head and neck, and a wide-angle lens is ideal for taking in more of the scenery. Photo courtesy of Steven D. Price

ahead and shoot them as they ride past you again, all your subsequent pictures will be of horse's tails and people's backs.

It's poor trail riding etiquette to pass other horses if they're going at a reasonable trail speed. A lot of horses don't like to be passed. It becomes a contest with them, and their riders have to hold them in check. Narrow trails and rugged terrain can make passing a challenge too.

Once you've ridden ahead, you've got to get far enough in front of the trail leaders to allow time to turn, select your background, and frame your shot while they're still far enough away to use the telephoto setting on your lens.

Then, as they pass you again, your horse will instinctively want to go with them again, and so it goes.

I speak from experience. When the American Quarter Horse Association started its Ride America program, I traveled to several states with the intention of taking magazine-quality photos at AQHA-affiliate sponsored rides. While I learned the pitfalls, I also learned some ways around them. For instance, if someone else is providing the transportation, ask for a short, patient horse and Western tack. I learned this after being given a 17-hand-high hunter at a ride in Florida; after I'd dismounted and photographed all the riders as they passed, I had to stick the company camera in the crook of a tree while I got back on.

These warnings are only to prepare you, not discourage you from taking your camera along for the ride. In fact, even if you aren't a big fan of either trail rides or photography, I encourage you to experience the combination.

Everything we've gone over in the preceding chapters will help you get better pictures on the ride. Here are some additional considerations:

Protect your equipment. When you aren't actually using it, put your camera in its case. Tie it securely to the saddle, preferably in two places, so it doesn't bounce around. Digital cameras are especially sensitive to dust and humidity. Use the camera strap, especially if you are shooting from horseback. If you have to loosen your grip on the camera to get better control over your horse, the camera won't drop all the way to the ground.

"A camera teaches you how to see without the camera,"
said photographer Dorothea Lange. Just as the world looks
different from the back of a horse, you get a renewed
perspective looking through the viewfinder.

⋀

Arrive early; stay late. Some of your best trail-ride photos may be of moments that weren't out on the actual trail. For one thing, the lighting might be better.

Look for candid photos of people saddling up or letting their horses get a drink at the water tank. A long lens is ideal here, as you can stand at a discreet distance and your subjects will behave more naturally.

If you are photographing an organized ride for a club or group's newsletter, try to let people know that a photographer will be present before they get to the ride. People will be more likely to dress appropriately.

Before moseying off down the trail, get everyone together for a group photo. It might be the best shot you get all day, plus you establish yourself as the photographer. If people know that you are photographing the ride, they'll likely be a bit more understanding if you gallop past in an attempt to get a good shot. They may even hold your horse or camera for you as you climb back on.

If possible, scout the trail ahead of time so you'll be prepared to make the best use of what nature offers. If you have to wait until you're actually on the ride, be sure you start out with the leader. When you find a good spot, you can drop out and photograph the other riders as they pass by.

To increase your odds of getting a good shot, look for places where riders are naturally going to slow down and spread out, such as water crossings or going down a steep slope.

Look for visual breaks between horses before you take a shot. Be aware when they appear to overlap or if one's head is cut off by the horse in front of it. Trail ride etiquette and common sense dictate riders leaving at least one horse's length between horses, but some tend to crowd together anyway.

❮ **This padded camera bag** is secured in three places, using the strap that came with it, the leather saddle strings, and a dog collar at the bottom, cinching it to the billet. (Photography teaches creative problem solving.) Having it anchored down keeps it from bouncing when you speed up, protecting your camera as well as your leg. By putting it on the right, where a cowboy would carry his rope, you have easy access.

⌃ **A group photo** at the beginning of the ride or workday makes a nice memento for the people involved, plus it establishes you as the group's photographer. They'll be more understanding if you break ranks in pursuit of photo opportunities.

Time your shot. Be aware of where the horse is in his stride as well as in relation to the background.

Visualize how the background or foreground can frame horses and riders. A tree branch may provide a canopy over the trail, or a fallen log might add interest to the foreground.

Try vertical shots as well as horizontal. Framing a shot vertically often allows you to crop out unwanted elements or unnecessary elements. And it will make a more interesting arrangement if you want to group your photos of the ride on display.

Look at the "Big Picture." Some of the most beautiful shots are panoramas of the scenery, with the horses becoming just one element within

the photo, rather than the subject. Rather than filling the frame with horses, try zooming out and using them as smaller photographic elements within the landscape.

Unless the sky adds visual interest, limit the amount of sky that you include in your photographs. An overcast sky or one of flat blue without clouds is boring.

Zoom out. When taking horse portraits, I advised you to zoom in to the telephoto range of your lens if you have that option. Since we often want to include an entire line of horses, or the background scenery – in other words, to capture a wider angle of the scene—you'll often want to zoom out to take in more of the scene in front of you.

⋏ **The reflective quality** of water can add visual interest to a photo. On trail rides, water crossings or steep slopes are good places to shoot because the riders tend to spread further apart.

If you're going to be horseback, consider taking a one-time-use camera (or several). The wide-angle lens is ideal for taking in scenery, and you don't risk damaging a more expensive camera or lens.

▲ **Zoom out** and look at the horses as pictorial elements within the landscape.

To ensure sharp pictures, you might need to increase your shutter speed or change to "action" mode, if you have an adjustable camera. Not only are your subjects moving, your horse might move just as you press the shutter, causing camera shake and an out of focus photo.

Ride defensively. Stay aware of where everyone else is around you, even as you are looking through your camera's viewfinder. Don't assume they'll watch out for you, or that they can control their horse even if they

▲ **While toting** a camera can be a temporary hassle, you'll enjoy the resulting photos long after the ride. The tip of the horse's ear documents that the photographer saw this scene while on horseback. Photo credit: Steven D. Price

see you. Trail rides often attract the greenest of green riders who can be a hazard to themselves and others around them.

A red ribbon tied to a horse's tail isn't a fashion statement; it means he's a convicted serial kicker. Assume that all horses kick, but be especially wary of those tagged with a red ribbon.

Never forget that horses are herd animals. Even a horse that you think you know well may act differently when introduced into a new group. Be patient and think from his perspective.

[193]

16

Moving Pictures

How to improve your horse videos

VIDEO CAN BE VERY BENEFICIAL WHEN YOU'RE MARKETING A HORSE, showing riders where they might improve, or evaluating a horse's progress in training. Of course, a video is much more beneficial if it's well done.

General advice

■ If you borrow or rent a video camera, practice long enough to familiarize yourself with the controls before you waste the horse's time.

■ Minimize camera movement as much as you can. Viewers want to watch the horse move, not the entire picture. The ideal solution is a tripod or monopod. Improvise by resting the camera or bracing yourself on something solid like a fence rail or car hood.

■ Don't start recording with the camera pointing up at the sky or down at the ground, then search for the horse while trying to get him in focus. Frame your shot, either where the horse is or where he's going to be, before you start rolling tape.

■ Avoid wide-angle shots at close range, which tend to distort the horse's conformation. (As discussed in previous chapters, wide-angle shots are those where you zoom out as far as you can because otherwise the horse won't fit in the frame.) A wide-angle shot head-on at close range can make even a grand champion look more like a brontosaurus.

■ When the horse is traveling toward you, don't let him get so close you inadvertently end up in wide-angle mode. Give the rider or handler marker-points for the range you want the horse to stay in while you are shooting.

■ The only time shooting indoors, or on an overcast day, or in mid-day sunlight is preferable is when you need to be able to shoot in all directions. Otherwise, use the same technique as professional horse photographers. Shoot in the early morning or late afternoon light, when the angle of the sun more fully illuminates the horse's profile, and is just generally more pleasing. Shoot from a position where the sun is at your back.

■ Videotaping on an overcast day or in an indoor arena, though dreary, has one advantage: you don't have to worry about the position of the sun. The disadvantage is it doesn't show off the horse's muscling, coat, or the sparkle in his eye the way the sun's natural illumination does. Indoors or on an overcast day, infuse some extra color—for instance, a brighter blanket or more colorful clothes on the rider. Also, it's better to fill your frame with your subject than to let a lot of gray sky or plain walls and dirt fill up most of your screen.

■ If you're shooting in an indoor arena, if possible close all the exterior doors. Otherwise, when the rider rides in front of them, the subject is silhouetted against the brighter background. If you can't close the doors, stand with your back to them and shoot away from them.

■ Beware the audio track! Some cameras give you the option of turning off audio feature. Even if you can turn it off, you might not want to, because the ambient sounds add to the viewing experience. However, unless you have information the viewers might appreciate, like where and when the

You'll use much of the insight gained in previous chapters when you transfer your attention from capturing a still image to capturing a moving image.

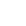

action is being taped and the horse's name, you might want to tape your mouth shut. Your voice will sound unusually loud compared to everything else because of your proximity to the microphone. And your inane remarks will sound increasingly inane each time you watch the tape.

When your goal is to sell the horse:

■ Have a plan—a script, if you will—before you start taping. This is especially important if you don't have the time, equipment, or patience to edit the tape after you shoot it. If you, the horse, or the rider makes a mistake, you can reverse back to the beginning of the sequence and shoot over it.

■ Remember to share the plan with anyone who is helping.

■ When possible, show the horse performing for real—not just in the practice pen. If he's a show horse, incorporate a clip from an actual show. If he's a rodeo horse, let's see him work in front of a crowd. If you're marketing him as the perfect horse to take for a Sunday afternoon ride out in the country, video him in that environment.

■ What is this horse's best selling point? His versatility? How impressively he jumps? That he's puppy-dog gentle? Whatever it is, make the point early on.

■ If your selling point is that this horse is ideal for kids or novice riders, don't limit the video to how well a professional trainer gets along with him. Show him with a kid or novice!

■ Remember such simple things as taking the horse's tail out of a braid, and clip that punk-rock bridle path. Think of this film as a first date. In a way, it is.

■ If you're taping a specific horse during a show, zoom in only on the horse you're trying to sell. An exception would be if he is obviously better than the other horses around him.

■ Use a fresh tape, instead of one that's been taped over time and again, to get the best possible picture. Also, you don't risk a distracting (or embarrassing) blip from your first wedding or whatever else you are taping over.

Specific tips for private treaty sale videos

■ Though a longer video is more acceptable when selling your horse by private treaty rather than at an auction, you're still better off keeping it short. A video is supposed to pique the buyer's interest, like a commercial. It isn't a documentary.

■ Even if you aren't marketing this horse as a halter prospect, include some clear footage of his conformation. Have him travel toward you and away from you at a walk and trot. If this isn't his strong suit, keep it brief and toward the end of the tape.

■ It doesn't hurt to add some quick shots to demonstrate the horse's ground manners: pick up his feet, bridle him, load him in the trailer, etc.

■ If this horse is really valuable, or if you're making a video to promote your stallion, breeding program, or training facility, consider hiring a professional video production company to do the final edit. Hire one that understands the horse industry, or else get a professional horse photographer involved in the taping, as mainstream production companies will have a hard time understanding what angles are flattering to horses, and why others are not.

Specific tips for auction videos

■ Keep it short. The ideal length is approximately two minutes, no longer than three minutes.

■ If your horse is on-site prior to the auction, place a television or monitor outside the stall and play your footage to show potential buyers what your horse can do.

■ Because the potential buyers can see both the horse and the tape, there's no need to use up seconds with conformation shots. Show them what they can't see in the sale ring.

■ "Loop" your finished footage, so that it repeats itself several times.

■ Start with the main selling point. For example, if he's a great roping horse, come out roping. Don't spend the first minute and fifty seconds loping circles followed by one ten-second run. If you want to show how your dog and four kids ride him backwards to prove he's also gentle, that's

great, but do it at the end. Conversely, if being gentle and easy to ride is his greatest selling point, the dog and four kids help dramatize the point and draw in the buyer who values attitude over athleticism.

■ Include a close-up shot to verify that the horse in the video really is the horse in the stall or sale ring, especially if you are recording in low light situations, which can distort the horse's color.

■ Have the tape queued up and ready to go before you give it to the sale staff. If they have to fumble around with rewinding or fast-forwarding, it destroys the momentum of the sale.

■ Write the lot number on the video cassette, CD, or DVD, not just the horse's name or your name.

■ When your tape is shown during the auction, the audio will be turned off. If it isn't self-explanatory, be sure the auctioneer has the details.

Afterword

WHILE EVALUATING IMAGES FOR THIS BOOK AND TRYING TO DEFINE
what makes a good horse picture, I came across many photos in my personal files that were technically flawed, poorly printed, or not particularly
flattering to the horse. Nonetheless, I'd saved them.

Going through those photographs turned out to be a sentimental journey. Some were great moments I'd witnessed at sporting events. Some
were pictures of my favorite equine athletes. And some, like this one, set
off an amazing chain reaction of memories.

Though I can't define what makes a good horse picture, I know what
gives one value: the viewer's connection to the horse.

Our efforts to take better pictures will often fall short, but the results
can still be significant. I hope this book encourages you to take more pictures, good and bad. As the hockey legend Wayne Gretsky pointed out,
"You miss a hundred percent of the shots you don't take."

Acknowledgments

For contributions directly related to this book: Johna Cravens, forever friend, who often helped me get roving thoughts out of my head and onto paper; the Dwight Hartley family, for sharing Stone Gate Ranch; Jim Jennings and the American Quarter Horse Association, for providing me abundant photo opportunities and permission to use some of the results in this book; Megan Nelson, who transcribed thoughts recorded from a moving horse; Steve Price, friend and "eddytur," for proposing this venture and never letting me quit; Erin Randall, who represented a fledgling photographer's perspective and contributed to the trail riding chapter and elsewhere; Reeves International, for supplying the Breyer model horses; plus Cowan Quarter Horses, Jimmy Eller, Tammy Reynolds, and Don Shugart, for help with the before-and-after photos.

For other contributions indirectly related to the finished product, like cheerleading, inspiration, opportunities, shared knowledge, and advice: Joe Atkins; Jim Banner; Alan Dale Brown; Darrell Burnett; Richard Chamberlain; Dayna Cravens; Tom Dorrance; Monte Foreman; Martha Hollida Garrett; Grady Groves; Mary Groves; Lillie Hart; Mark Herron; Susan Kanode; Ed Knocke; Nancy Kygar; Gene Krause; Rosalie Krause; Renee Lloyd; Clint, Mindy, Ben, and Janie Johnson; Beth and Jim Blane

Kenney; A. J. Mangum; Brenda Michael; Gala Nettles; Becky Ohlde Newell; Jennifer Barron Paulson; Marilyn Randall; Tom Ryan; Roy Jo Sartin; Dale Seagraves; Jon and Jody Semper; Don and Jan Shugart; Paul Skipworth; Dana Smith; Jessie Smith; Sam Smith; Doug Wiggins; Andy Wilkinson; George Williams; Jenny Wohlfarth; and the higher power that can't be alphabetized as the world has yet to agree upon a name.

Index

trail rides, 184, 187–88, 190–93
trotting, 120–22, 161, 167, 172, 175

V
videotaping, 195–99
viewing, 1–2

W
weather, 33
wide-angle lens, 44, 46, 49

Z
zoom lenses, 38, 42–43, 46